DOORS

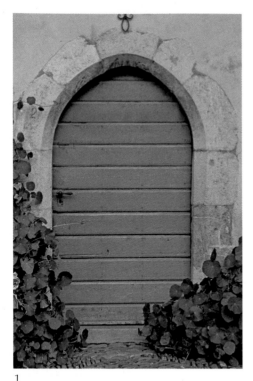

1

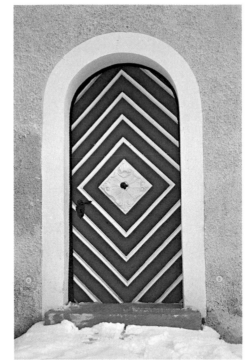

2

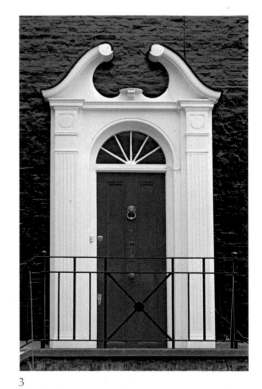

3

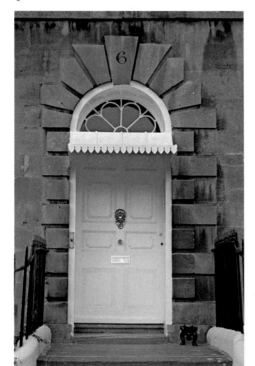

4

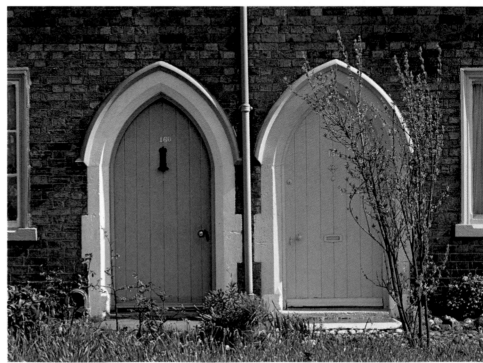

5

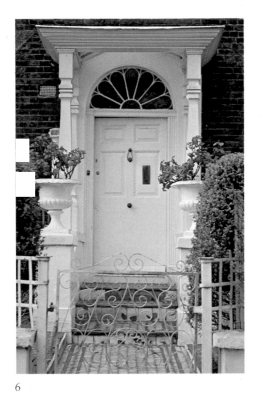

6

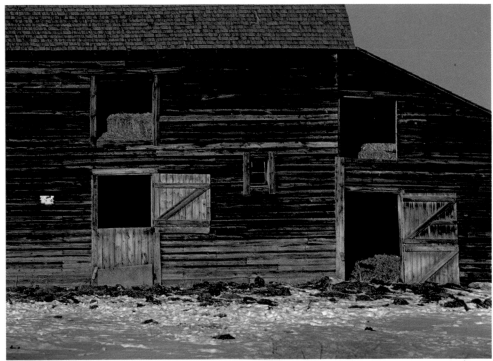

7

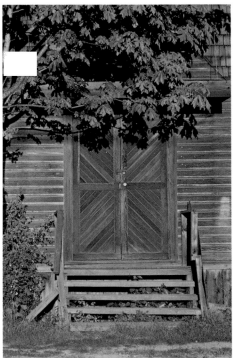

8

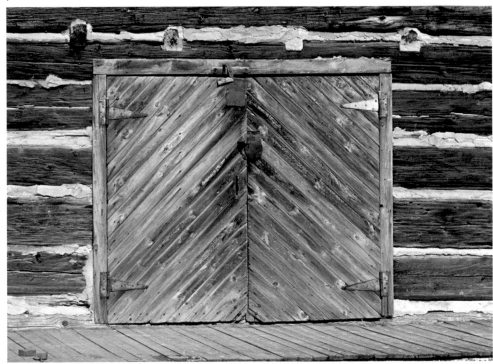

9

*If a man write a better book, preach
a better sermon, or make a better
mousetrap than his neighbor,
though he build his house in the
woods, the world will make a beaten
path to his door.*

Ralph Waldo Emerson

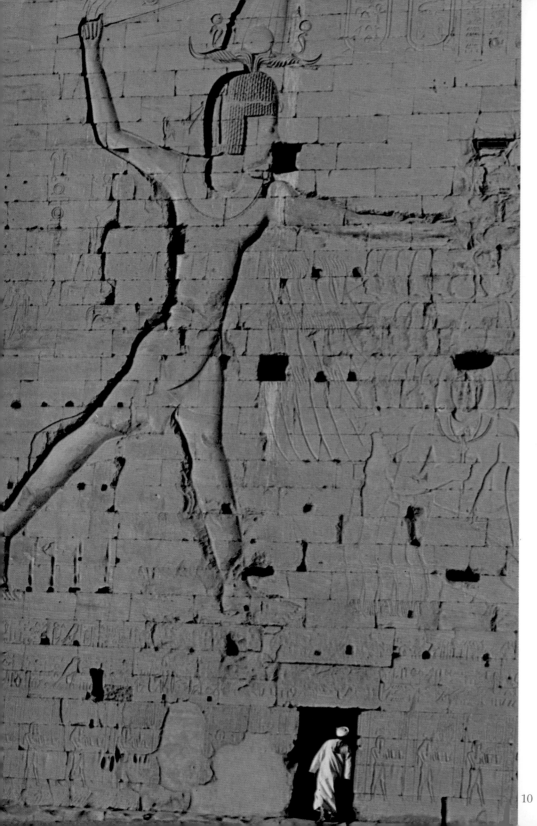

DOORS

Text by Val Clery

Photographs by Gordon Beck, John Bigg,
Bill Brooks, John de Visser, Peter Dominick,
Ted Grant, Rudi Haas, Jennifer Harper, G.J. Harris,
Uta Hoffmann, Charles Kadin, Fiona Mee, Bill McLaughlin
Barry Moscrop, Wim Noordhoek, Murray Sumner and
Robert van der Hilst

A Jonathan-James Book

A Studio Book
The Viking Press, New York

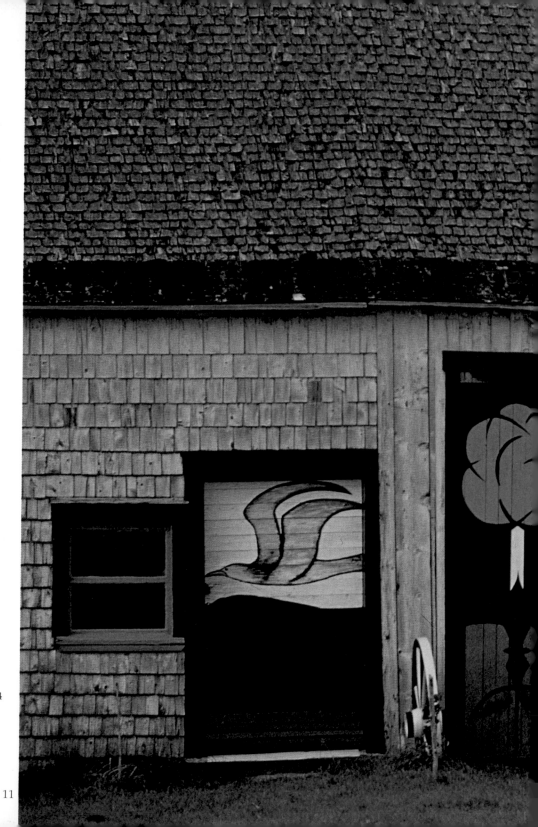

Library of Congress Catalog Card Number: 78-63154
ISBN 0-670-28039-9

Printed in the United States of America
by R.R. Donnelley & Sons Company
Set in Aldus

11

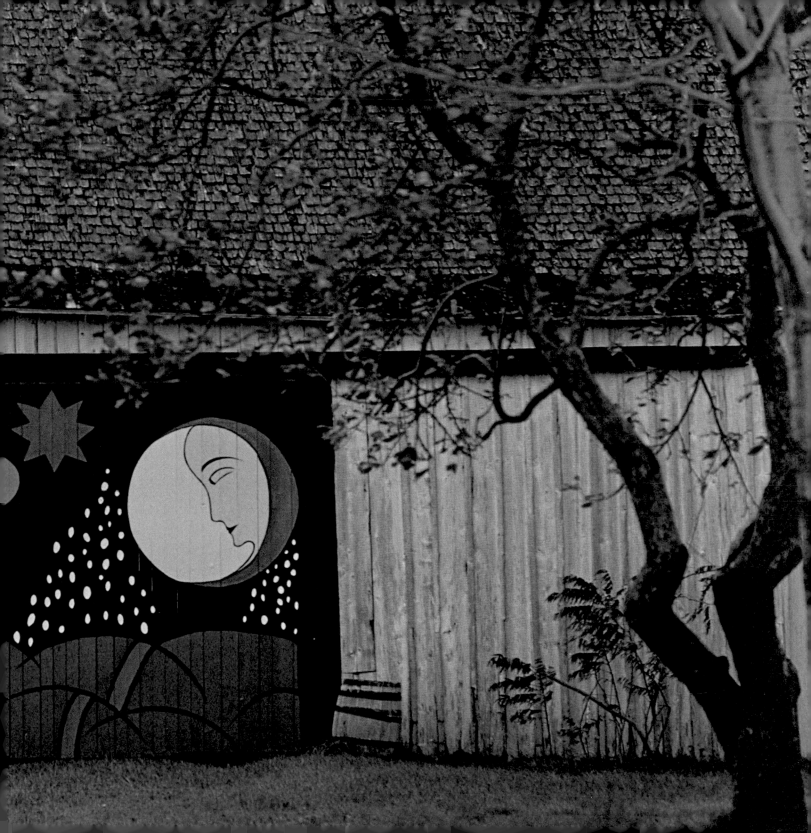

If windows are the eyes of a house, a door is its mouth. Windows are passive, doors are active. Through windows we glimpse what is and what happens, but when we pass through a doorway we encounter and most likely become involved in what lies beyond.

Doors remain closed to tell us of our rejection or of another's seclusion, doors open to welcome us or to engulf and imprison us, doors frame our farewells or joyful reunions or tearful reconciliations, doors slam like periods at the end of scenes of anger or frustration or bewilderment, doors beckon us to a haven when the world has become too demanding or wearying or threatening and enclose us in love and warmth and familiarity, guarding us solidly from peril and weather and the unknown. Yet doors admit surprises and delights, fresh air, new friends or long-lost lovers, good news, unexpected gifts, longed-for responses, the quick kindness of neighbors, the regular brisk cheer of the mailman.

The frontier crossings between outside and inside, between social and personal, between public and private, between Them and Us, doors mark out our moments of truth, our points of contact, on their hinges swing our fates, through them we go from one passage of our lives to another, retreating, arriving, departing, returning

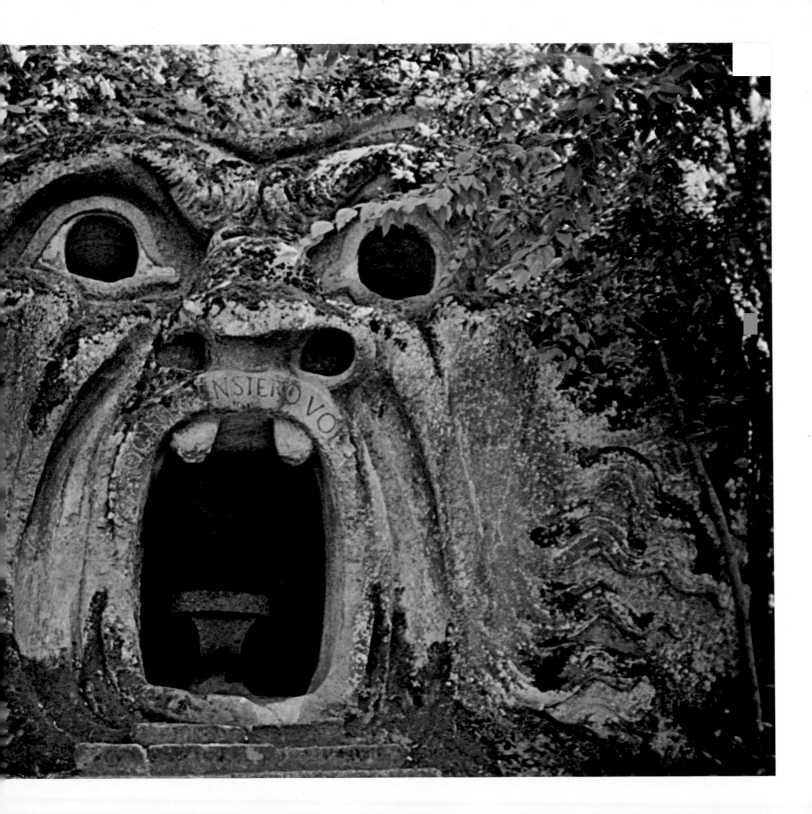

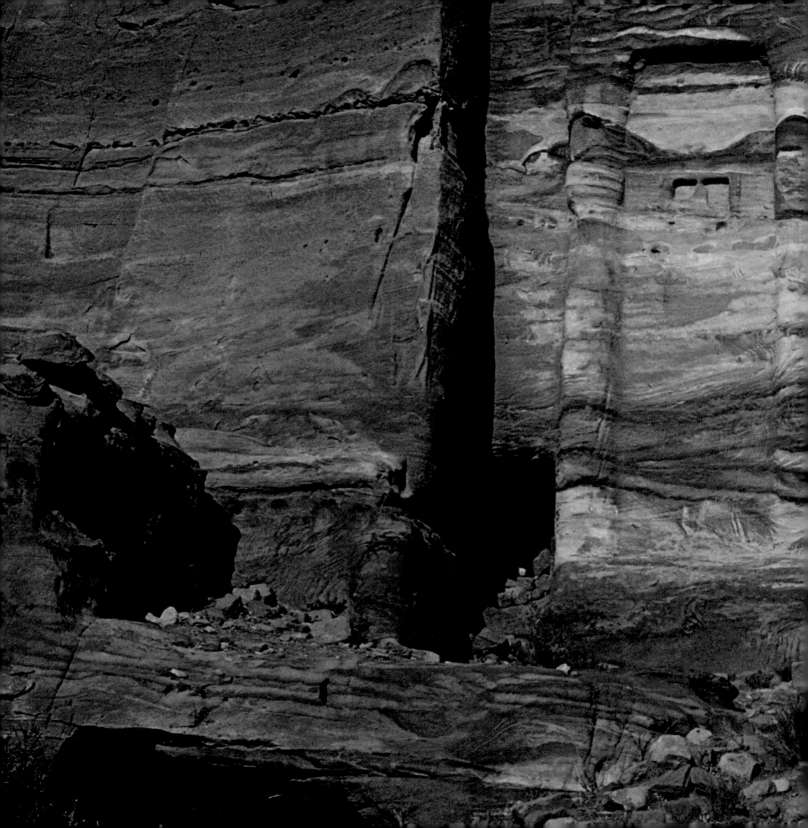

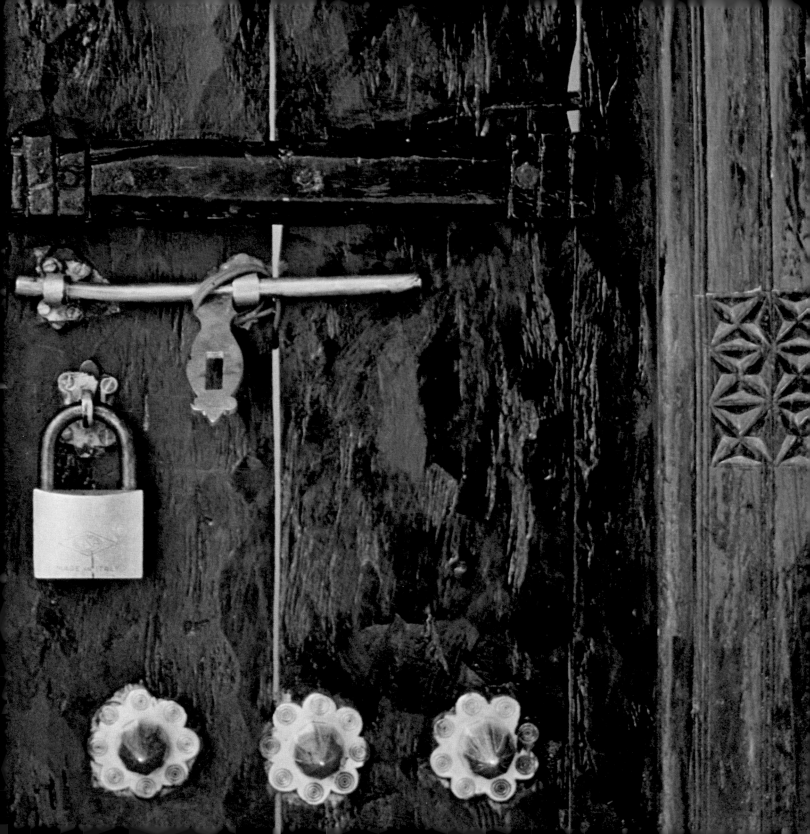

Lock your door and keep your neighbors honest
English proverb

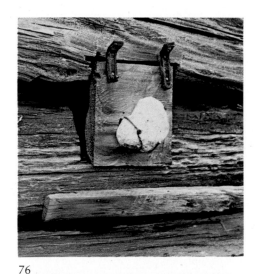
76

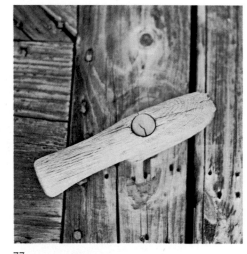
77

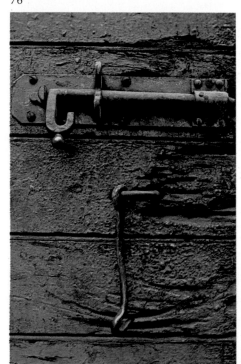
78

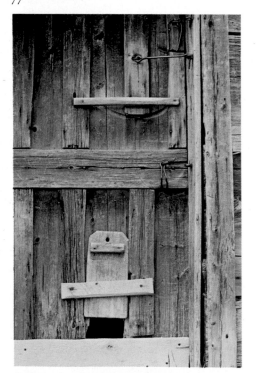
79

Doors, for all the ends to which they have been adapted, were primarily intended to provide security from intruders. There are still many communities, small and secluded for the most part, where householders boast with communal pride that they never bother to lock their doors. It is usually in these same communities that the main function of bolts, latches and locks is to keep livestock in rather than keep intruders out.

Country people share an easygoing attitude to doors and to security. There is no

great hurry about the daily round, so it is no problem that a weathered gate or door sags on its hinges and has to be slowly and laboriously eased open or shut. Factory-made bolts or hinges have to be fetched from the general store in town, so surely such hardware can be contrived from a few nails and screws and a scrap of wood. And if it works well enough, why go to the bother and expense of getting the real thing?

Never bolt a door with a boiled carrot
Irish proverb

80

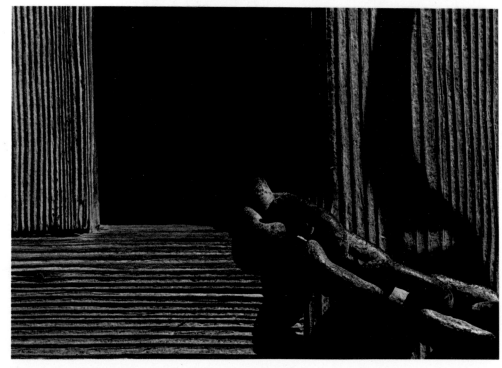

81

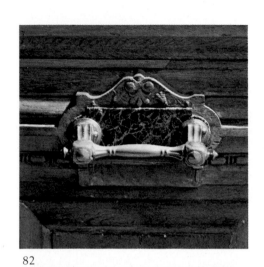

82

83

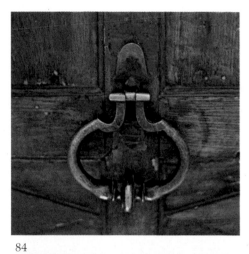

84

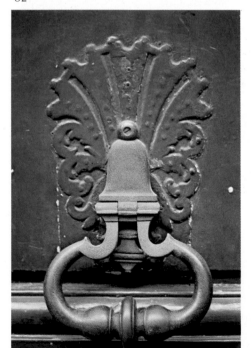

85

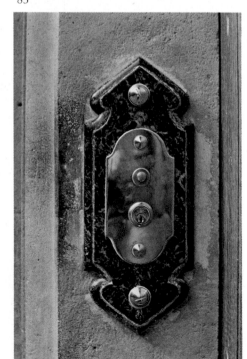

86

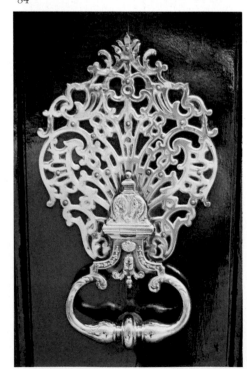

87

When I was a lad I served a term
As an office boy to an Attorney's firm.
I cleaned the windows and I swept the floor,
And I polished up the handle on the big
front door.
I polished up that handle so carefully
That now I am the Ruler of the Queen's Navy.
W. S. Gilbert: HMS *Pinafore*

In cities, however, door fittings must not only secure the lives and possessions of the householders but must also secure their social standing. Handles, door-knockers and bell-pushes, if they are well-polished and of superior design, can do as much for the prestige of a house or professional establishment as an expensive, neatly-tied necktie might do for a man's image. Unlike many of the doors to which it is attached nowadays, door furniture is rarely

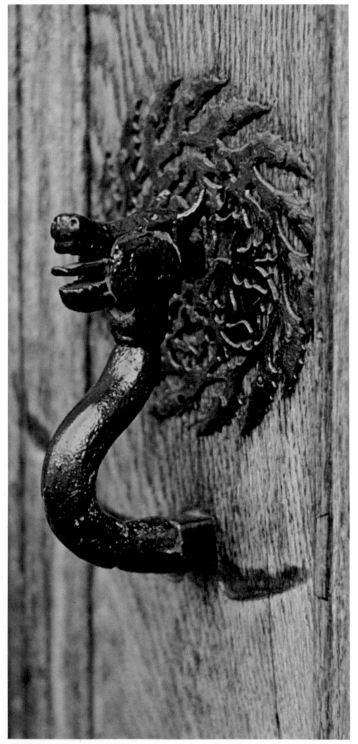

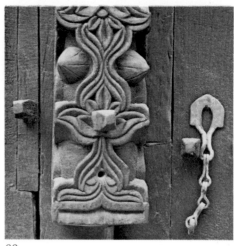

89

mass-produced; it tends to be made, in infinite variety, by small local manufacturers or foundries.

An unwelcome innovation is that electronic device set into the door-post into which the visitor must shout his name and business before the door is electrically unlocked. But there are still bells and door-knockers in use, by the design of which the house-owner may establish his status, and by the manipulation of which the visitor can signal both his character and his mood.

Only in the gates of antiquated convents do grilles

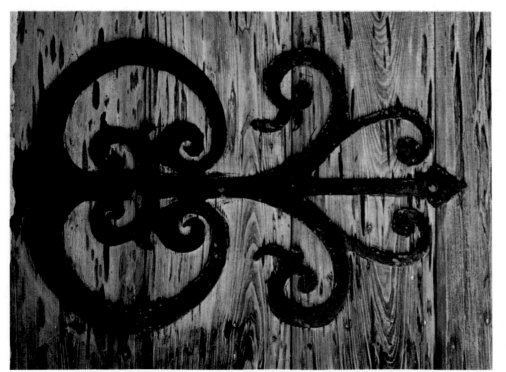

90

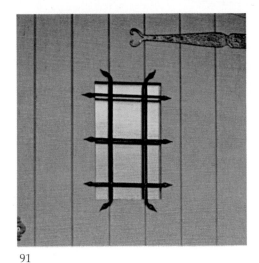

91

survive, and those in our
relaxed times lack the
romantic significance they
had when Don Juans whis-
pered escape to rich rebellious
novitiates. There is little ro-
mance in viewing the eye of a
romantic lover through the
magnifying glass of a
present-day spy-hole.

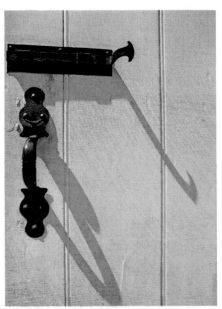

92

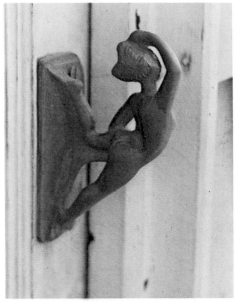

93

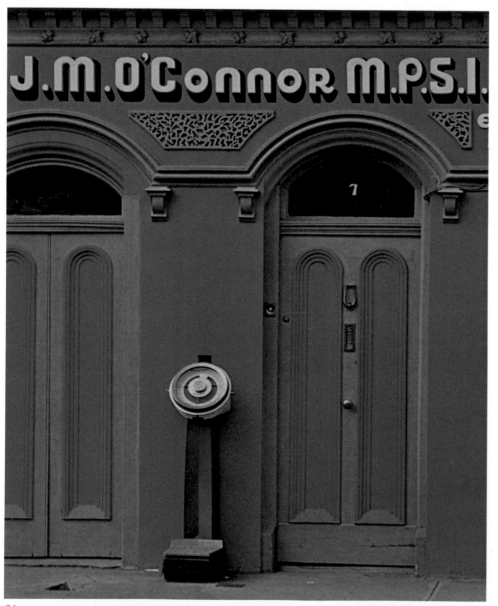

There are the doors we scarcely notice, of course, no matter how often we pass through them—the doors of familiar local stores. We are usually so intent on remembering what we need to buy, what quip or greeting we offer the friendly pharmacist or grocer, that only the warning tinkle of the bell that marks our entry reminds us that there is a door at all. Unless we arrive too late and are informed by the card hung inside its glazed panels that the store is "Closed". Then it becomes the most noticeable obstructive door in the world, stolid against our attempts to open

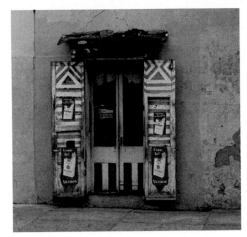

it, tauntingly revealing exactly what we intended to buy in the shadows within—yet no glimmer of light or sign of the store-keeper. We have now every reason to ignore such a door the next time we enter.

Barbershop doors should always be wide and open and on the shady side of the main street. With perhaps a curtain of beads or ribbons to keep out the flies—but not if that obscures a clear view of all that is happening outside, for what more easeful joy is there for a man than to be carefully shaved or barbered while watching the world go about its business?

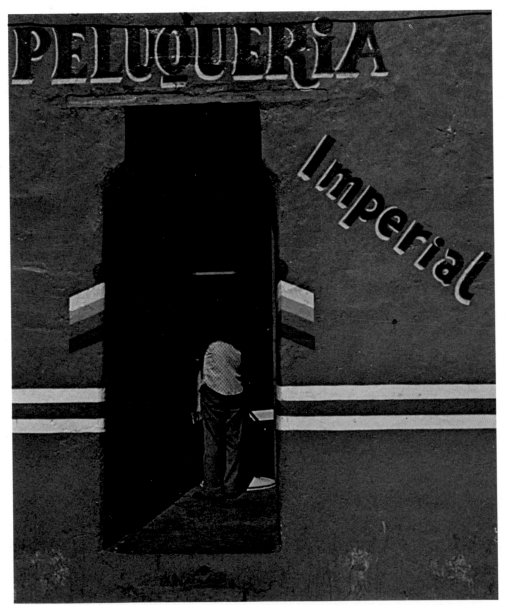

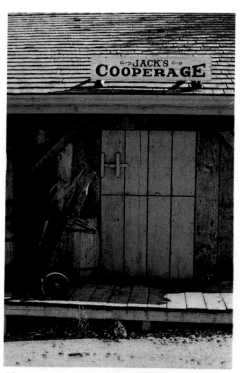

Craftsmen's doors too should always be open. By law every curious child or inquisitive adult should be entitled to peer inside, smelling the sawdust and hot iron, enjoying the noise and bustle, seeing how barrel staves are sawn and moulded, how the hoops are shrunk on and the ends fitted. Or for that matter, how horses are shod, churchbells are cast, or books are bound. As long as there are barrels and horses and bells and books around.

When they have disap-peared, all we will have left to wonder at is what lies behind the sullen obdurate doors of windowless warehouses. Occasionally when the many-wheeled leviathans of the freeways back in at dusk and the doors grind back on their rusty rollers, we are allowed to glimpse a shadowy interior mountain of unin-formative crates, to see them hefted forward by whining forklifts, and to hear the rumble of loading and the final clank of the tailgate. The monster snarls and roars, and

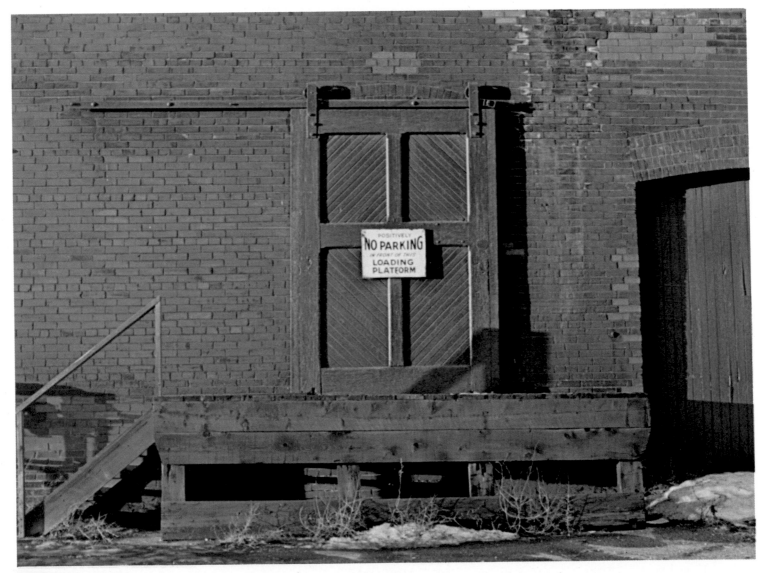

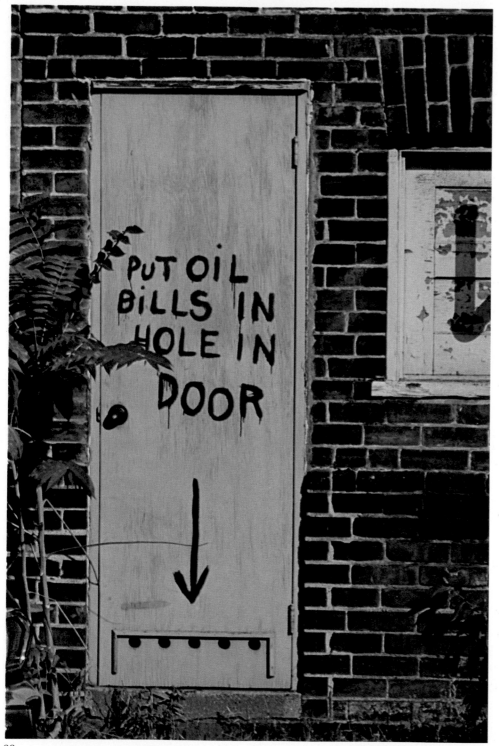

lumbers off towards the night and the freeway. Already the door has ground to a close, and we are left staring at the "No Parking" sign and wondering what is in there.

The fact remains that doors seem incomplete without activity. Windows are essentially static, to be looked into or out of, but doors need to be walked through. They are there to allow arrival and departure, and if they do not serve that purpose they might as well be windows or even just walls.

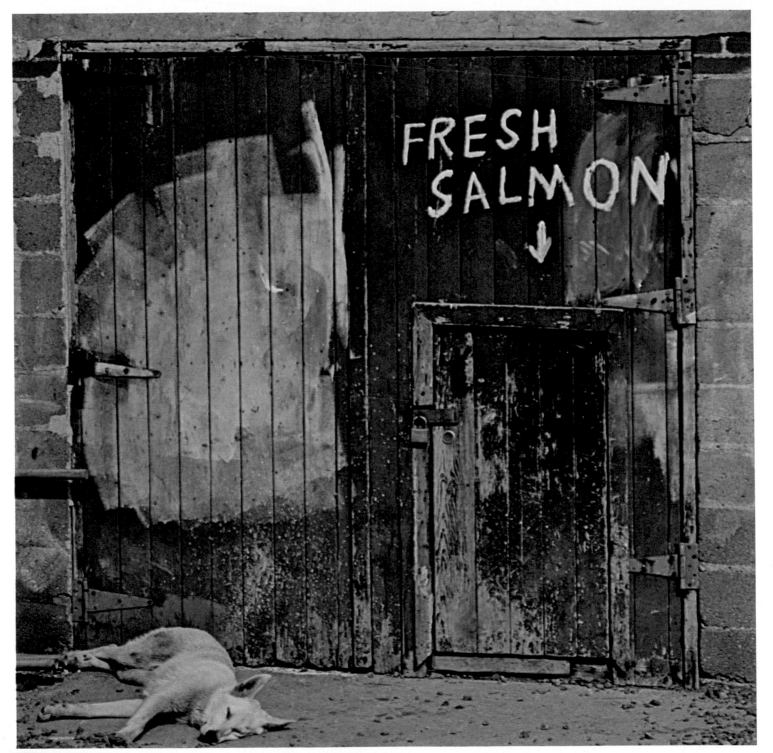

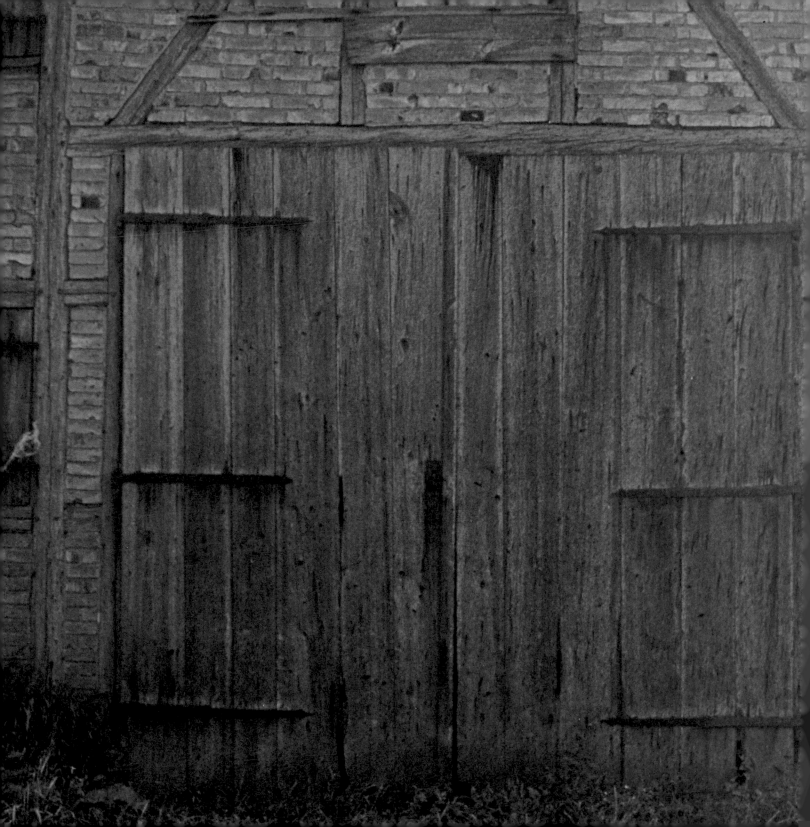

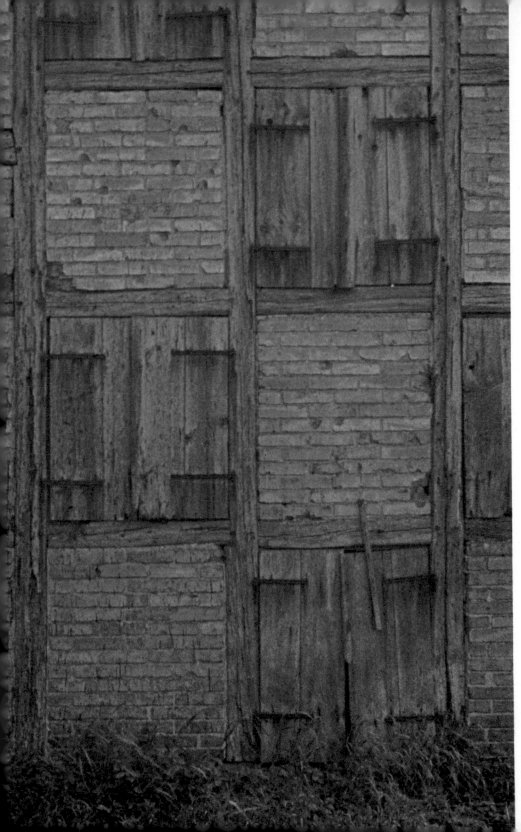

The proverb may advise us to lock our doors and keep our neighbors honest. Another cautions that an open door may tempt a saint. But it could be argued with equal point that a closed and bolted door may tempt a sinner. It is not beyond possibility that fewer burglars are motivated by avarice than by curiosity, or at least by the challenge issued by the locks and bolts of closed doors.

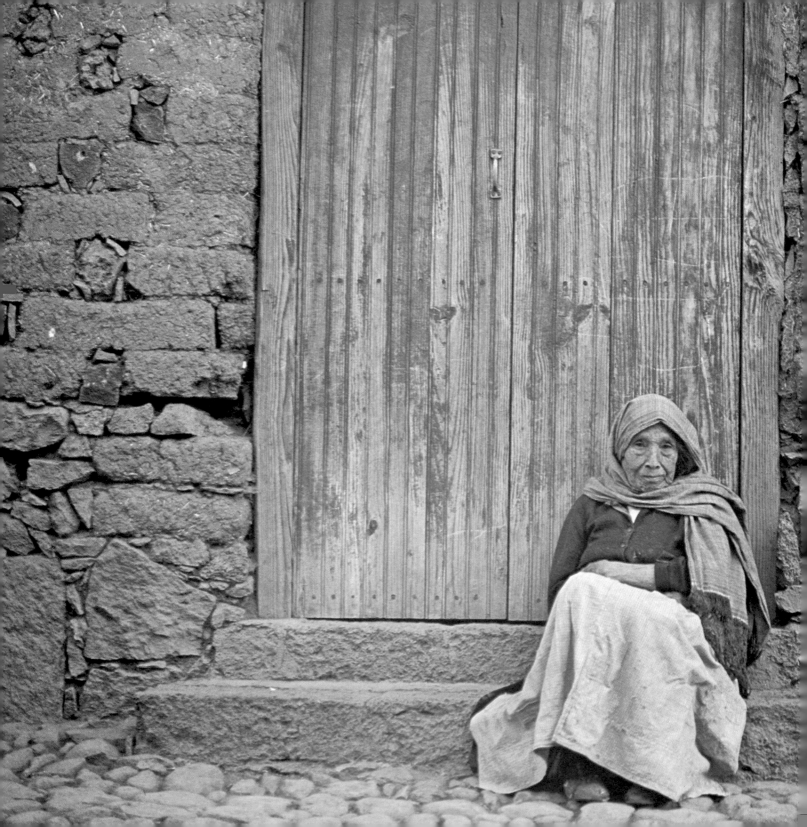

*Do not flee conversation, and
let not your doors be always
shut*
Ovid

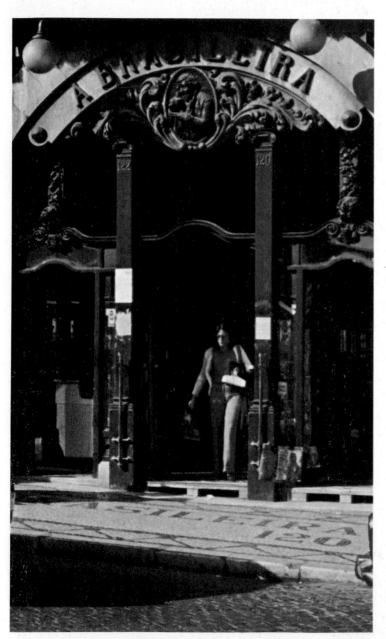

The most popular
coffee-house in
Lisbon, where seats
are rarely empty and where
lively conversation and
strong sweet coffee mingle
freely throughout every day,
probably owes its popularity
in large part to the inviting
generous proportions of the
graceful open doorway. Only
the obsessively diligent
passer-by could resist its invi-
tation, with the added seduc-
tion of murmuring talk and
rich aroma that wafts over the
sidewalk.

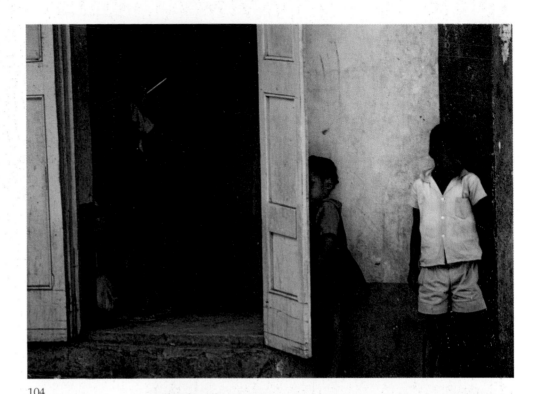

104

All open doors are seductive, and when the sun is out and time slows down, the superstitions that warn against lingering on thresholds are invariably forgotten. Children play hide-and-seek while their parents casually pass the time of day with a friendly merchant. A family holds idle council in the gentle waning sunlight with the day's work done and the evening meal over. The threshold is the hearth of the summertime.

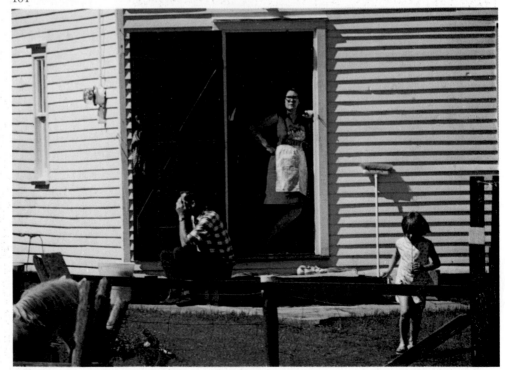

105

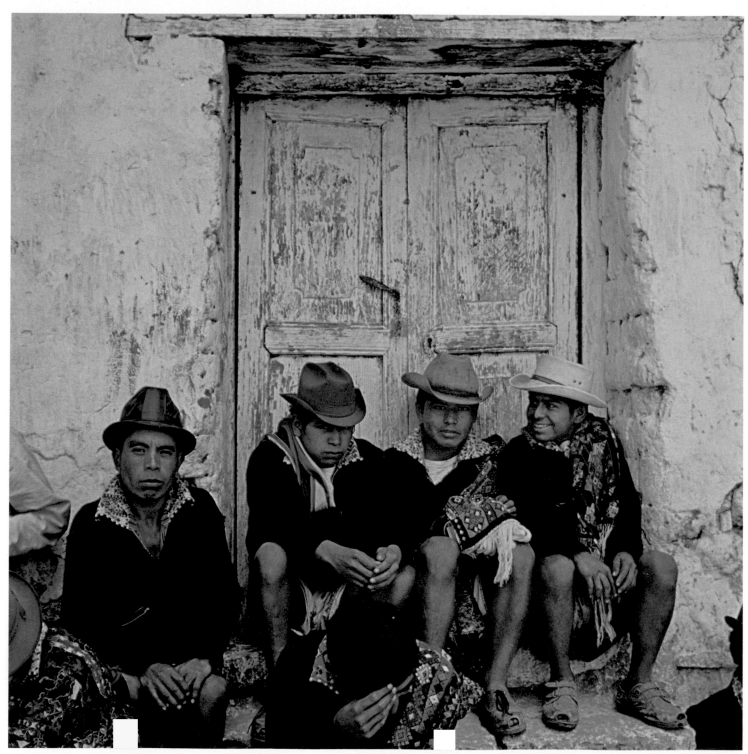

If you are old or if the season has brought work to a pause, what better grand-stand than a doorstep—there to join the acquaintances of a lifetime and ruminate on the perversities of the weather, the iniquities of the govern-ment, the way things were, and the idle ways of women-folk.

Meanwhile, across the street, as neighbor helps neighbor to fix her hair, neither feels that a chance to watch the ways of the world should be wasted in the dull privacy of a back room. Open doors are meant for open eyes.

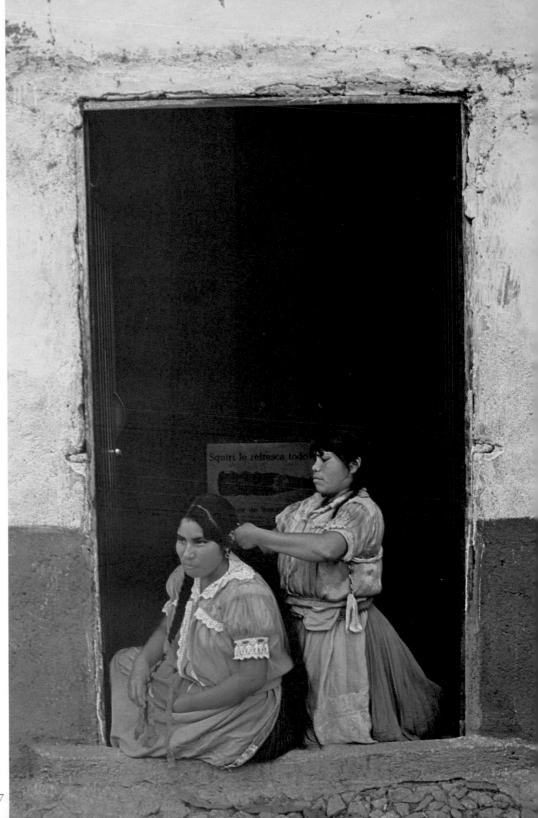

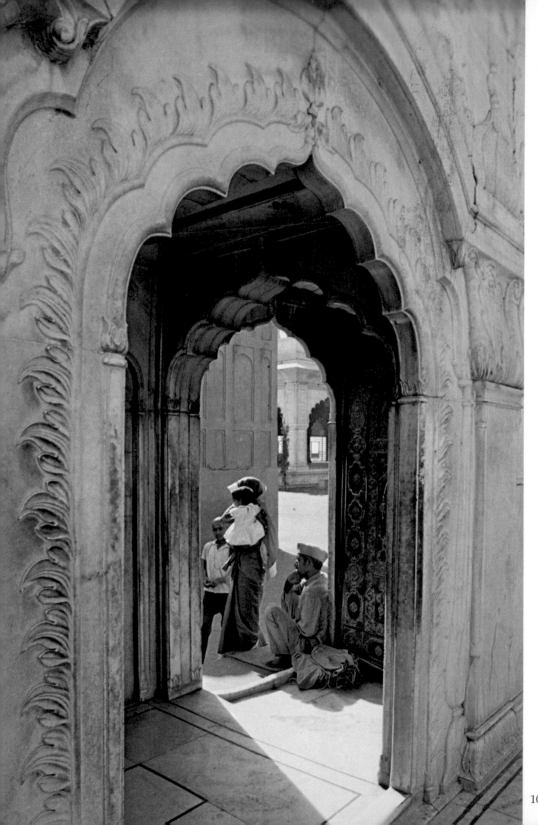

Open doors provide the
family album of a neighbor-
hood. As we stroll along the
streets, doorways frame
snapshots far more natural
than those caught self-
consciously before the hyp-
notizing camera. A pair of
neighbors rapt in gossip,
father and son in rigid con-
frontation in a hallway, an
old woman on a front step
bowed in remembrance of
some long-past joy or sorrow.
We dare not stop and stare,
for that would be an intrusion
and would break the spell.
But a glimpse out of a corner
of the eye is enough to print
the snapshot on the mind; we
can develop it as we stroll,

108

speculating on what had so absorbed those neighbors, on what misunderstanding had set son against father, on what moment of so many years ago the old woman was brooding.

There are two sides to an open door. We can linger in our own doorways and watch the mystery movie of the street. Why is this neighbor hurrying in that direction at this time of day? Who is that stranger strolling by? Who would he be visiting? And all the better if you have a screen door to veil your curiosity. And keep out the bugs and flies, of course.

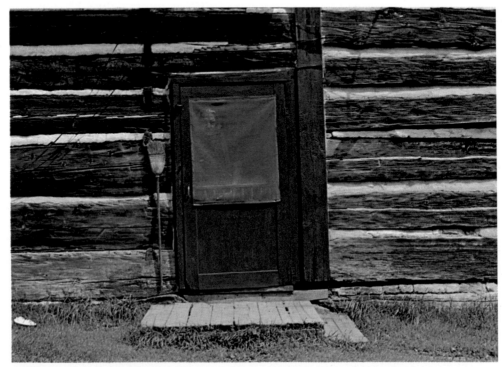

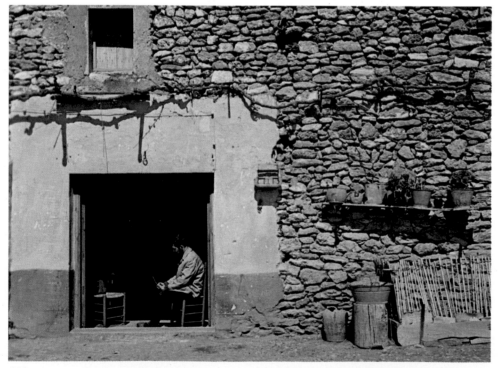

Because they have framed those arrivals and departures that mark every lifetime with sadness or happiness, doorways stand out more vividly in our memories than other parts of home or workplace. A son setting off for a distant war, a daughter apprehensive in her finery for the church and then a new home of her own. The shadow of a changed half-remembered friend suddenly falling across the threshold; even the eager daily return of children from school, hungry and rambunctious . . . These are all recalled, as visibly as when they happened, as you stand

now in that self-same doorway.

It may be the doorway you went to day after day to watch the sky, hoping to see the rainclouds that might save a parched crop. Or better the doorway from which you could see your husband and sons harvesting, gauging the time, from the angle of the sunlight past the eaves, when you should carry out the noonday meal. The doorway from which you watched for the doctor coming along the road, the same doorway from which you heard the thin cry of your firstborn in the bedroom within, at which you

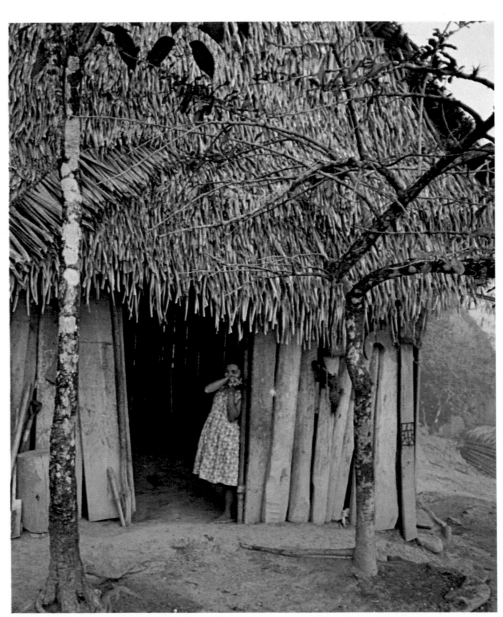

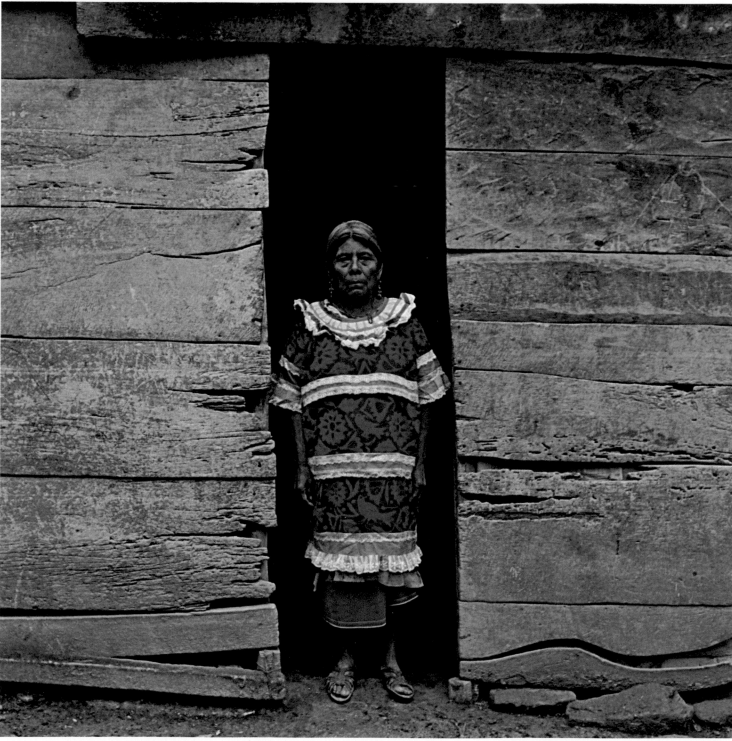

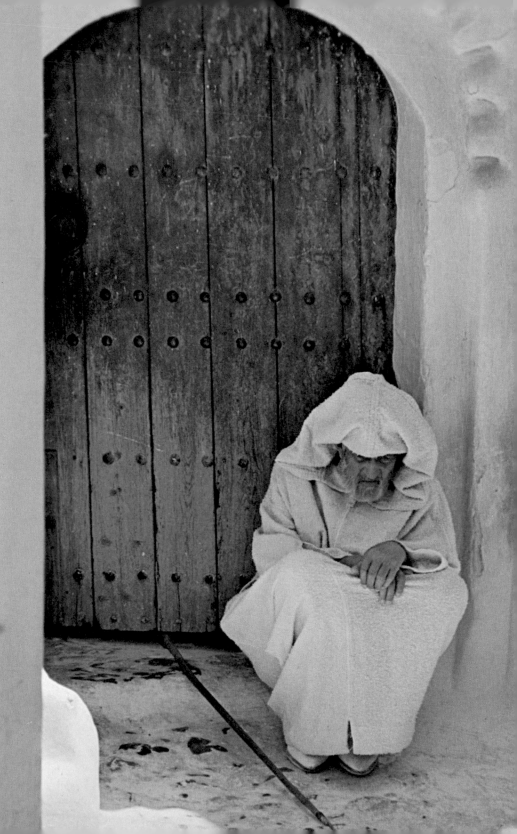

welcomed guests for the chris-
tening, and then the doctor
again, and another thin yell;
that day it was raining and the
boy was beside you eager to
know if he had a brother or a
sister...

Now there are only the
marks on the doorpost, where
you measured their heights as
the years went by. They have
their own doorways now.
Soon perhaps they'll be
bringing their children to
see where they grew up,
and you'll be waiting for
their arrival at this same
door.

Yes, the years are mea-
sured out at doorways.

113

I am the door.

Gospel According to St. John,
Chapter 9

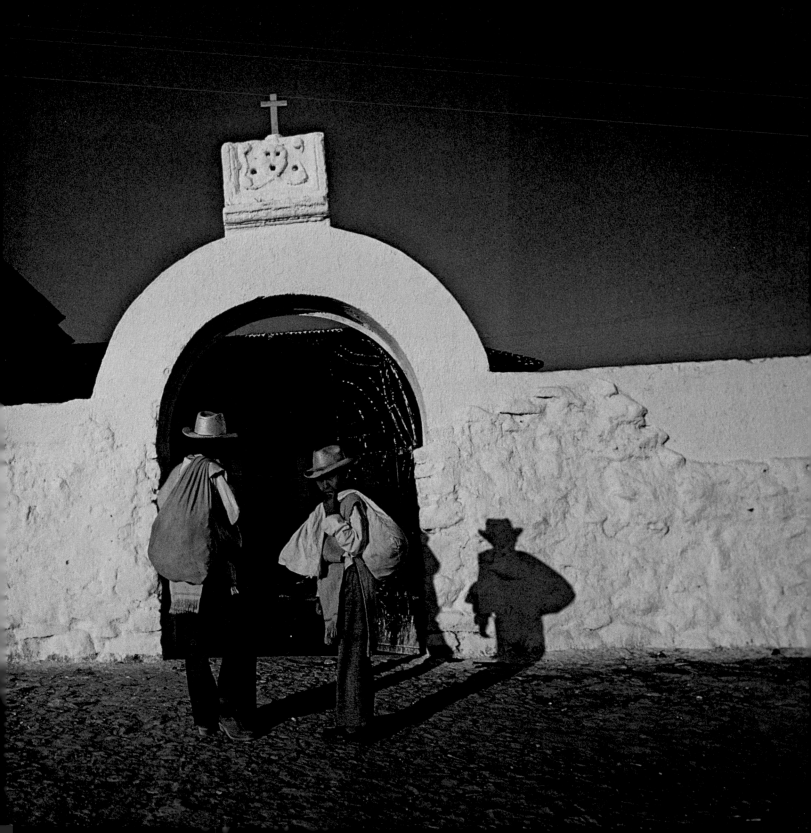

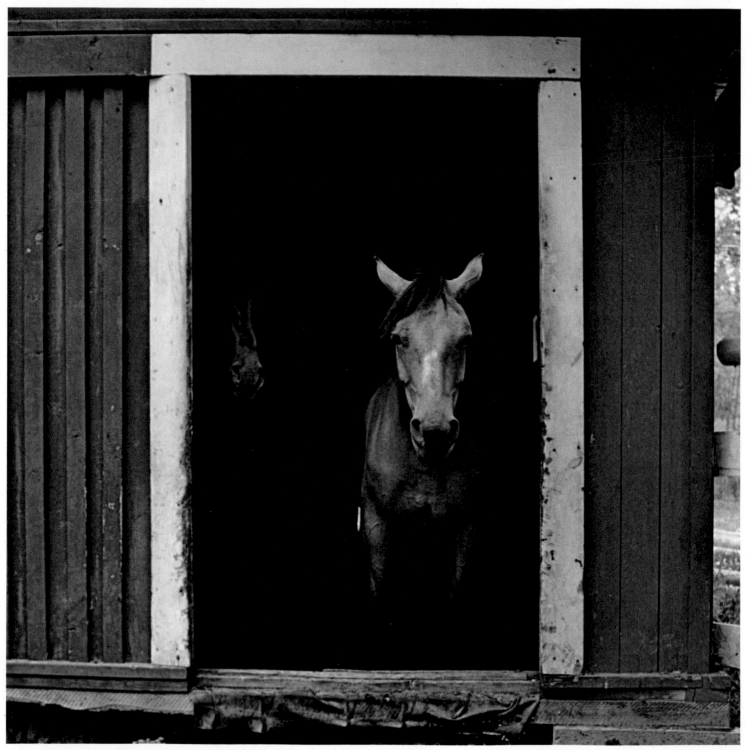

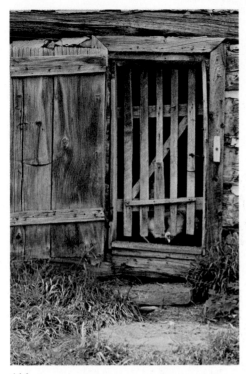

116

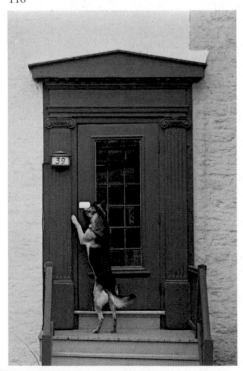

117

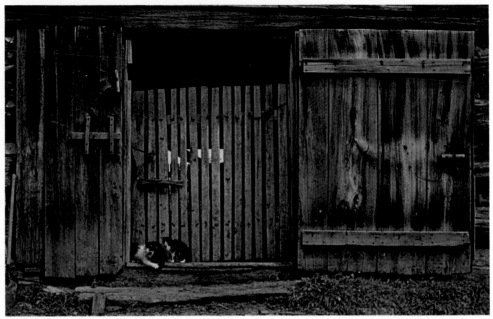

118

orses are indifferent to doors. If there's hay in their stalls, they'd just as soon stand head to the wall and munch it. If not, they may stand in the doorway and remind someone that it's coming up to feeding time. Or maybe they'll watch the less noble animals making fools of themselves around the barnyard.

Chickens have no patience with doors or gates. When they're inside one they are frantically certain that outside the ground is thick with scraps and grains, theirs for the pecking. And glistening thick worms writhing helpless on the grass, that the crows and pigeons will steal. When they're out, chickens will go to any lengths not to go back inside. They know they'll be expected to settle down and lay. They'd sooner lay around.

Cats despise doors. They know that no house is proof against their stealth; there will always be a transom they can reach, or a window ajar. And besides if they pretend to sleep on the doorstep in the sun, a silly bird may hop too close.

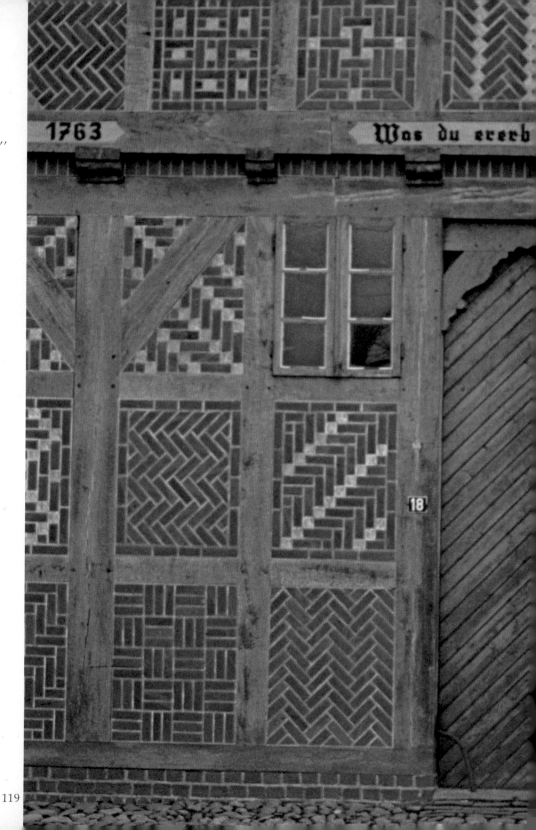

A door is what a dog is perpetually on the wrong side of.
Ogden Nash:
"A Dog's Best Friend Is His Illiteracy"

1763

Was du ererb

18

ountry doors do not have to seem other than they are. They are built to endure, and to serve practical purposes, not to impress. Farmers generally share a liking for what fits in with the nature of the countryside. Wood that looks like wood, even if it needs to be soaked in preservative, but not wood glossed over with paint; wood that will show its grain and strength, retaining some memory of when it stood as one of a proud stand of trees

119

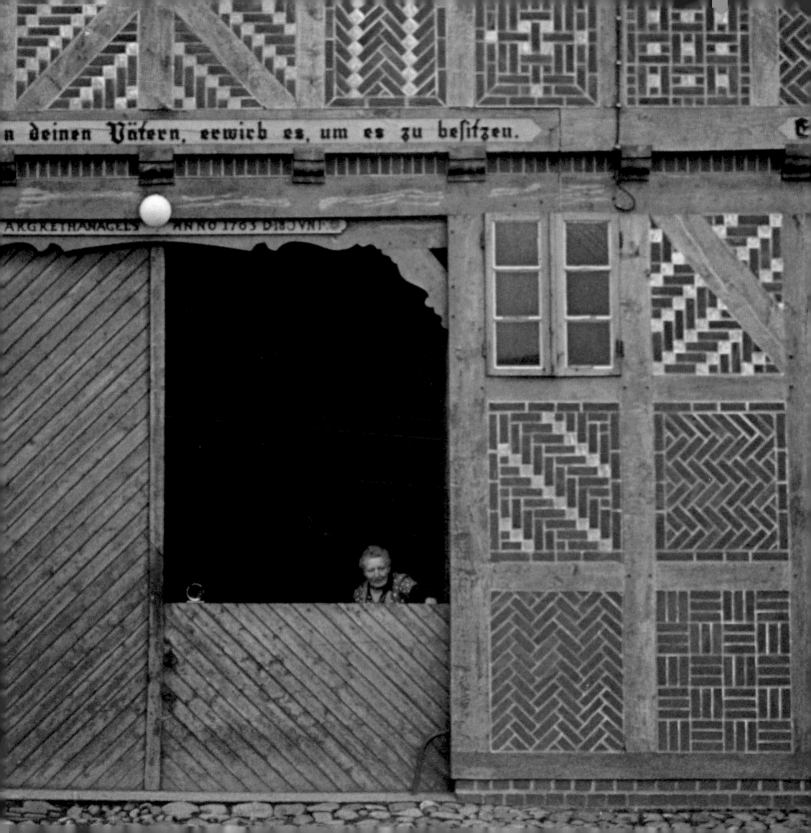

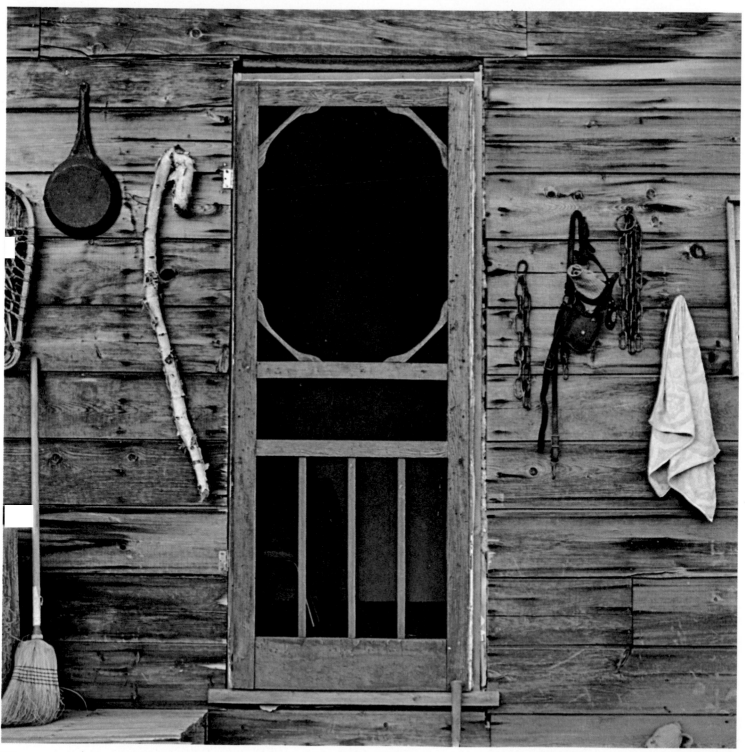

before it was felled and hauled off to the sawmill.

Wood that you can still almost feel the life in as you lean on the half-door of the barn in the evening. A great good door, well made by your own hands. Heavy enough nearly to break your back these chill mornings when you have to let the cows out to pasture; it will probably begin to sag soon like the doors on the older outhouses. But no matter, a door that you'll always be proud of, that'll long keep the weather out and the cattle in.

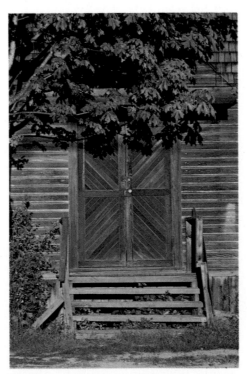

121

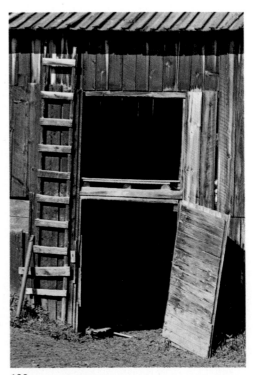

122

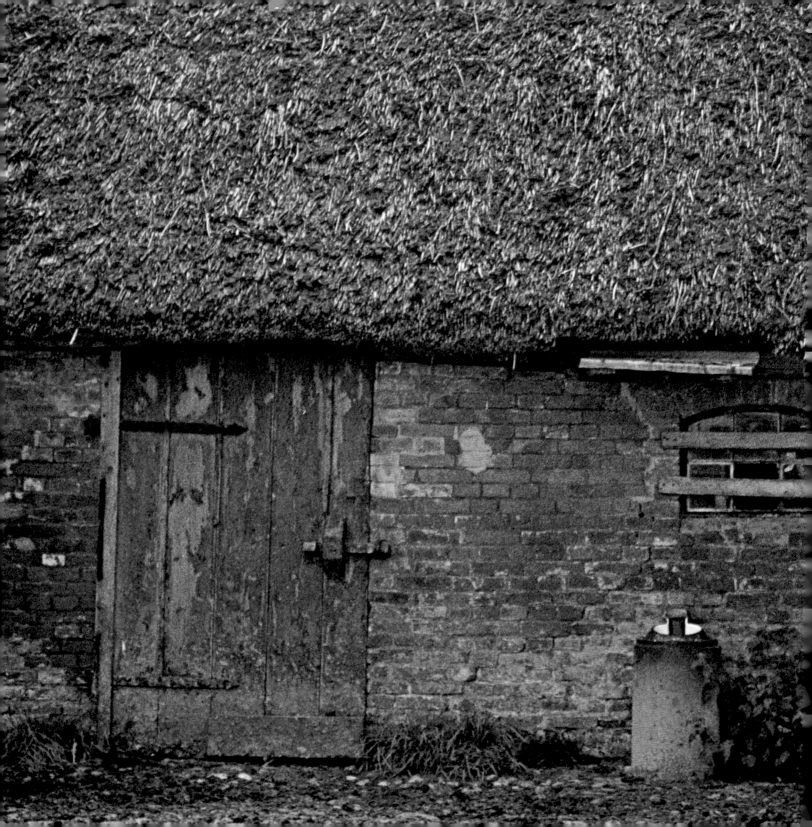

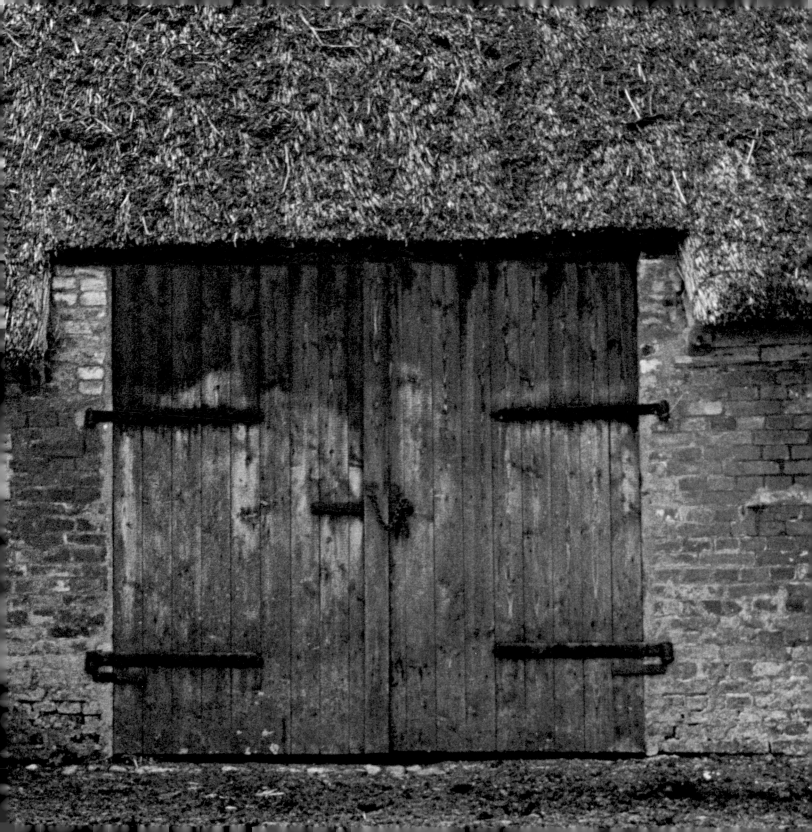

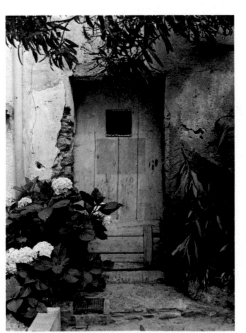

125

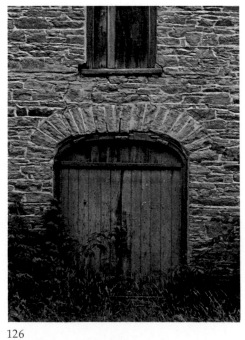

126

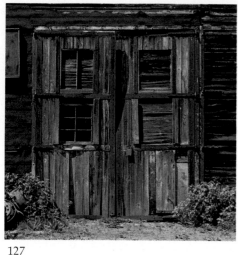

127

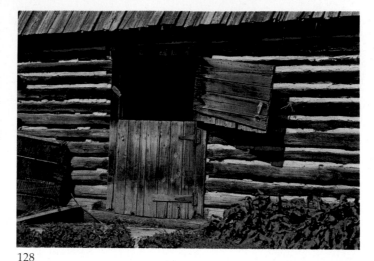

128

As farming becomes less a way of life than an operation of business, such doors as these, roughly etched with the story of hundreds of seasons, are likely to become curiosities. With doomsday warnings forever sounding of future global shortages of food, smaller older farm-steads are being engulfed into what are dully described as economically viable agricultural units. The old buildings are bulldozed down and the venerable wood of their doors and walls and roofs is either burned or sold to a city jobber who can sell it at a tidy profit as decor for some modish cocktail lounge or restaurant.

Even on those small farms that do manage to survive, those original sturdy doors that are still in use are likely to be the last of their kind. The men who knew how to make them are either dead now or too old to begin again. And with the farm-belts long ago cleared of woodland, the lumber needed would be too expensive. When eventually they have rotted beyond repair, such doors will have to be replaced by lighter machine-made doors of metal or fiberboard that will swing easily and efficiently on their hinges but will have no story written upon them of how the land was cleared and how a farm was built on it and how its doors served a family through their years and grew old gracefully with the man who made them.

We must eat of course, and prosper, but can we live to the full if we close the door on all else?

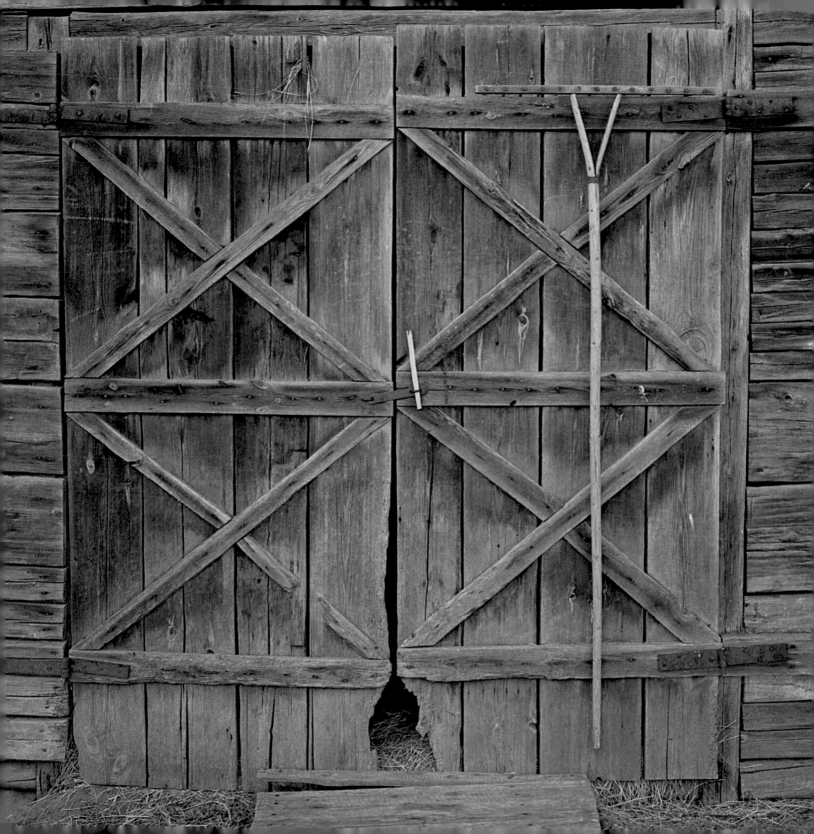

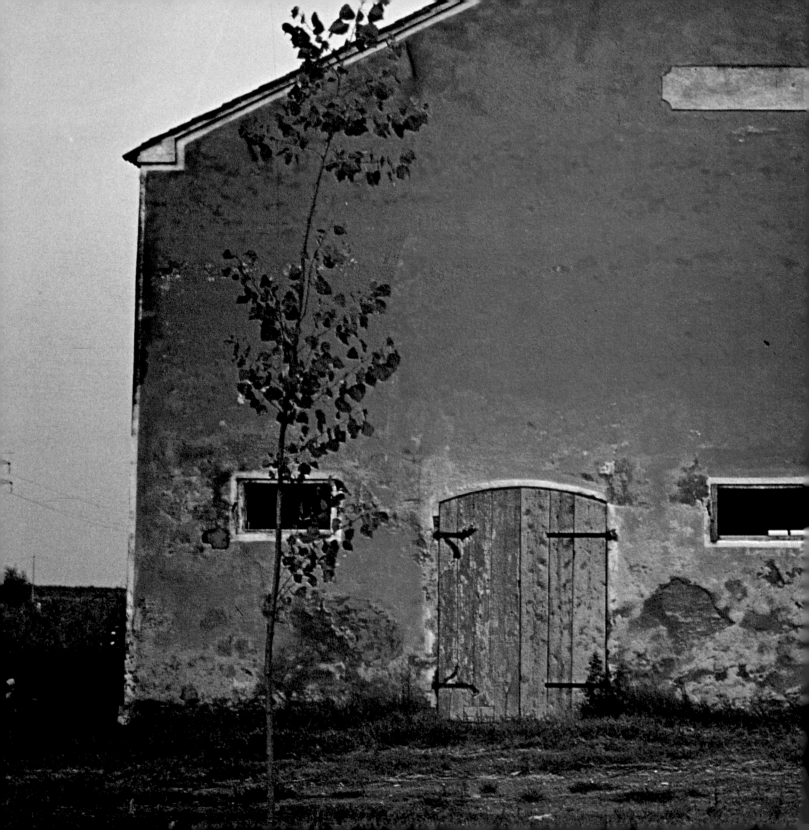

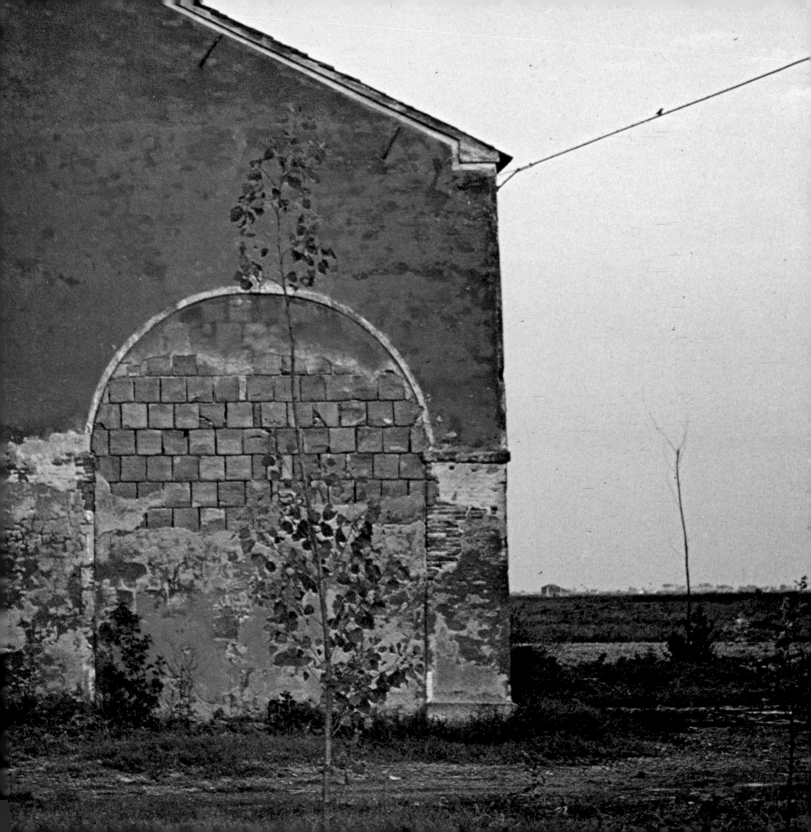

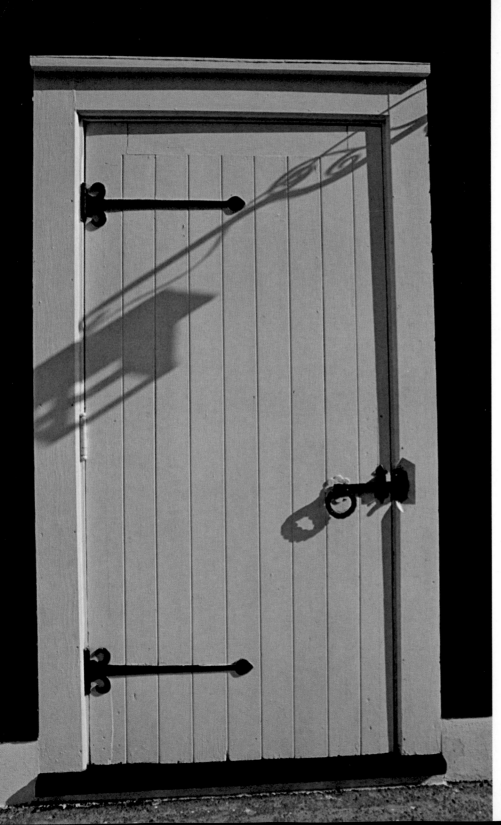

*Men shut their doors against
a setting sun.*
William Shakespeare: *Timon of Athens*

*Already the iron door of
the north
Clangs open: birds, leaves,
snows
Order their populations forth,
And a cruel wind blows.*

Stanley Kunitz: *End of Summer*

133

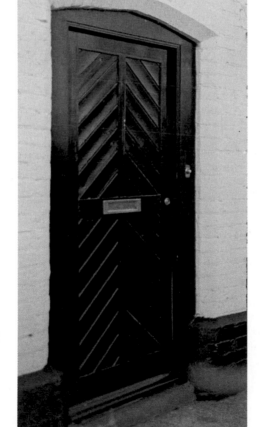

*I have been here before,
But when or how I cannot tell;
I know the grass beyond
the door,
The sweet keen smell . . .*

Dante Gabriel Rossetti: *Sudden Light*

132

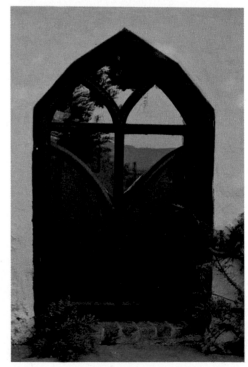

134

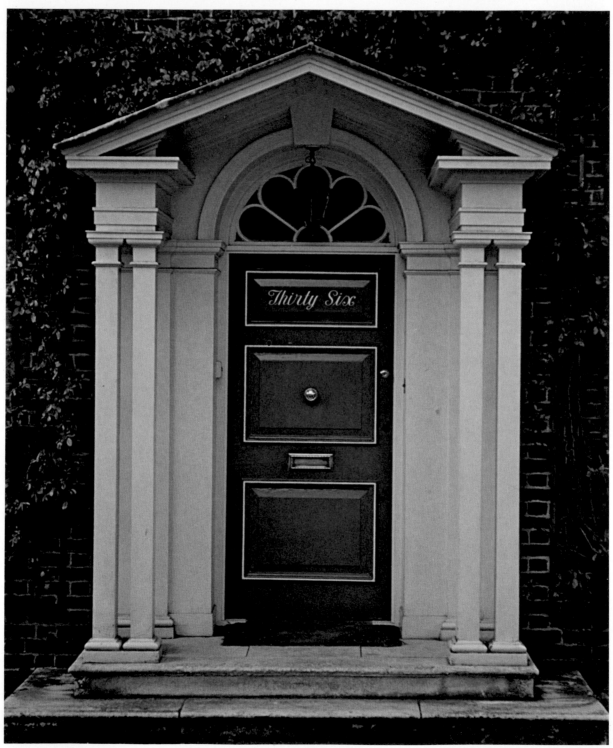

135

The English have always placed a great value on privacy and on the sanctity of the home. "An Englishman's home," so the saying goes, "is his castle." And even if the English home did lack battlements and a moat, its door was usually imposing and solid enough to deter presumptuous intruders. The English classical doorway of the nineteenth century, when class distinctions began to take on monumental proportions, was quite as explicit in its message as the medieval castle gate with its coat of arms. If its Georgian proportions, its elegance and dignity were not enough to impress, there was usually a plaque nearby announcing "No Hawkers, Peddlers, Or Tradesmen". These underlings were consigned to a "Tradesman's Entrance" at the rear or side of the mansion, or possibly down a narrow flight of steps at basement level, there to be rebuffed by a member of the household's domestic staff. Even social equals could not merely drop in for a chat. An afternoon tea or luncheon had to be preceded by a calling card, with a subtle inscription, deposited on the silver salver of the footman who swung open the splendid if formidable door. An invitation might return.

It would possibly have perturbed the Christian English gentleman who owned such a doorway that the noble columns that flanked it derived from primitive dwellings that were constructed of bundles of reeds, or that the spokes of its arched fanlight were possibly related to pagan sun-worship. Since the English upper classes, schooled in Greek and Latin, considered Rome the inspiration for their own imperial affluence, they were less

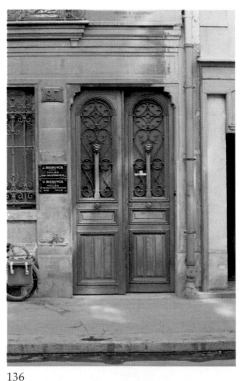

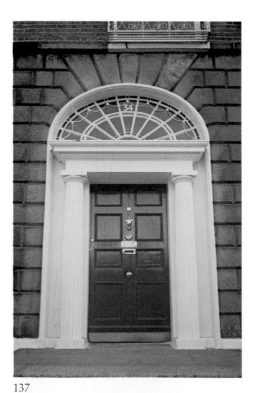

perturbed by the fact that their doorways drew also from Greco-Roman classical design.

The Georgian doorway established itself wherever English commerce made its mark: in Boston, New York, Philadelphia, and Dublin. In the American South, where porches and verandas were a climatic imperative, the style reverted to variations of the more expansive Palladian style.

In Europe over the same period the doorways of the

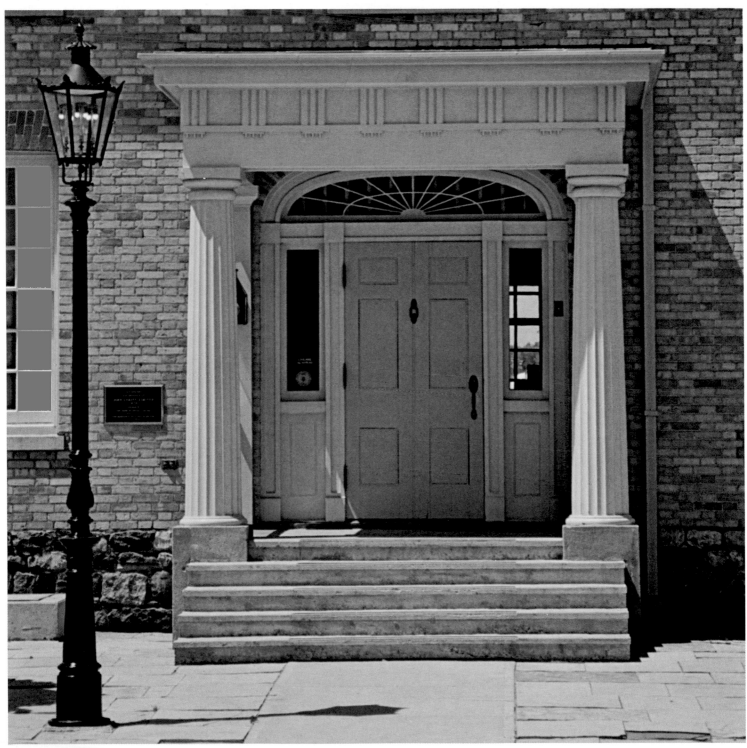

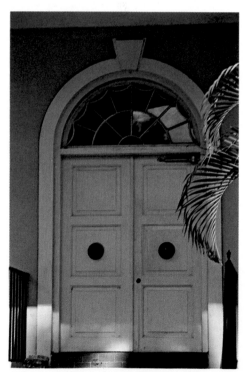

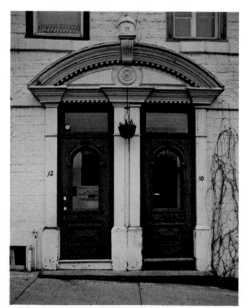

rich, long beset by war and civic strife, were far less arrogant in their design. Even when they allowed themselves the extravagance of double leaves, there was a defensiveness in the glazed upper panels guarded by strong grilles of decorative ironwork.

As well as privacy, the English valued a measure of conformity. Those haughty Georgian doorways in London and Dublin were usually set in the continuous facades of town house

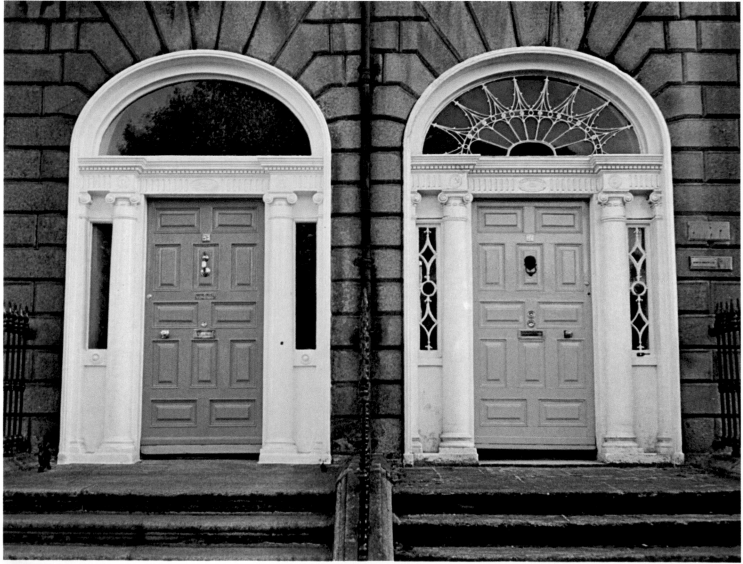

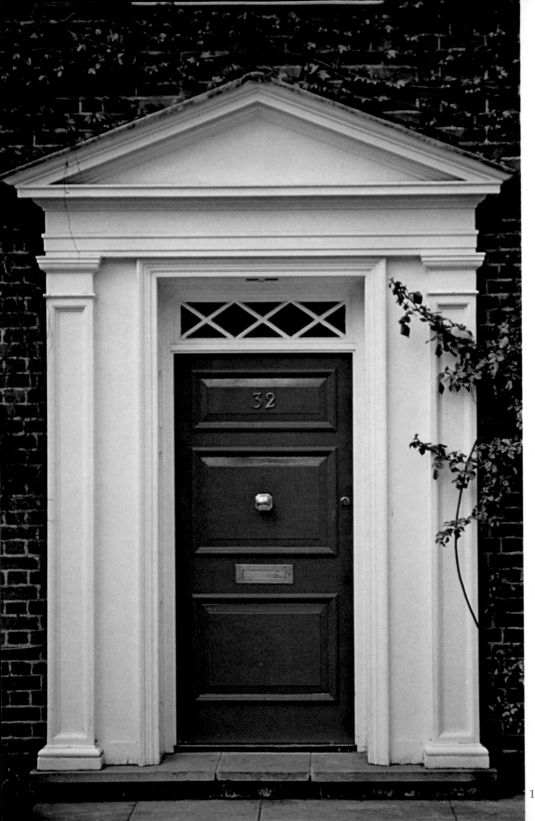

terraces and crescents and while at first glance they give an impression of uniformity, they were permitted nevertheless a wide variety of detail in their frames, panelling and fittings.

Such doors were built to endure. But there are no longer English gentlemen rich enough to maintain the vast houses behind them as town residences, and there are no longer footmen to sweep them open and receive calling cards. Instead they now house smaller branches

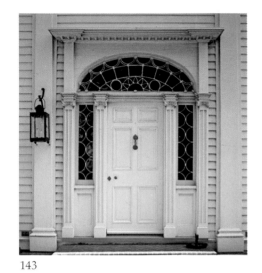

143

of the civil service, or the managements of public utilities, or professional associations, or they are divided up between medical specialists and fashionable dentists. But the gleaming overweening doors maintain their air of privacy and impassive gentility.

Georgian doorways, even after the decline and fall of the British Empire, maintain a stiff upper lip.

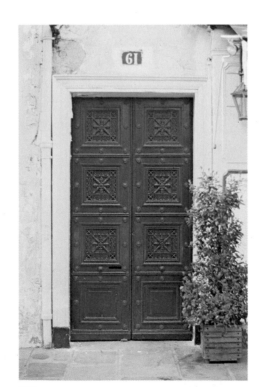

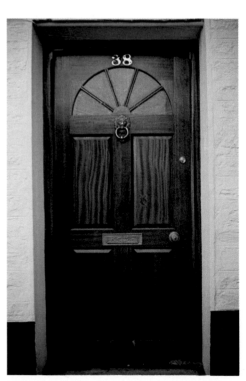

144

145

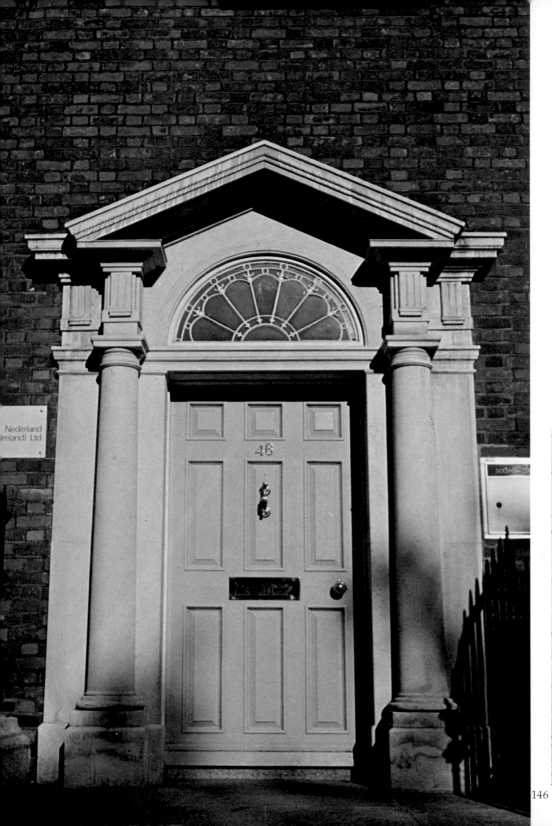

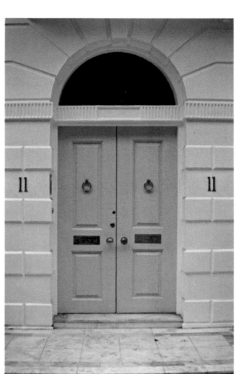

146

147

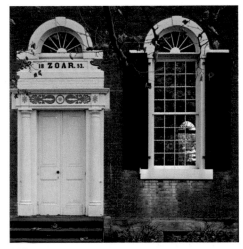

148

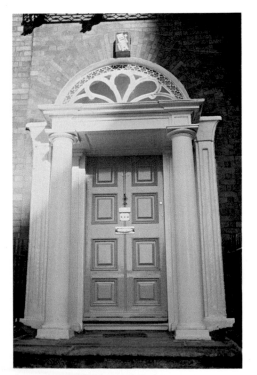

149

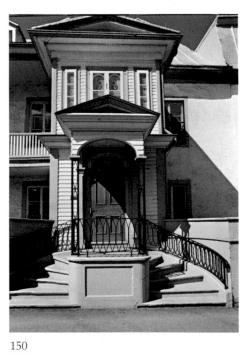

150

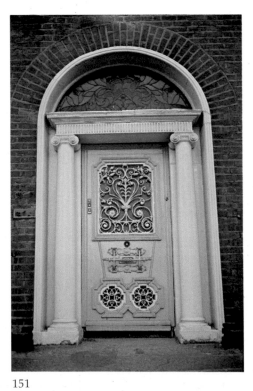

151

O pen doors and gate-
ways are promises.
They imply progress,
discovery. Instead of
rejection they offer us an
invitation, if not to enter at
least to look.

Architects of real vision
never use doorways merely to
exclude or divide; they so
arrange them that they serve
to focus attention on some
vista of grace or beauty
beyond, framing another
doorway, or a glimpse of
garden, an enticing succes-
sion of rooms, or the upward
spiral of a stairway. Their

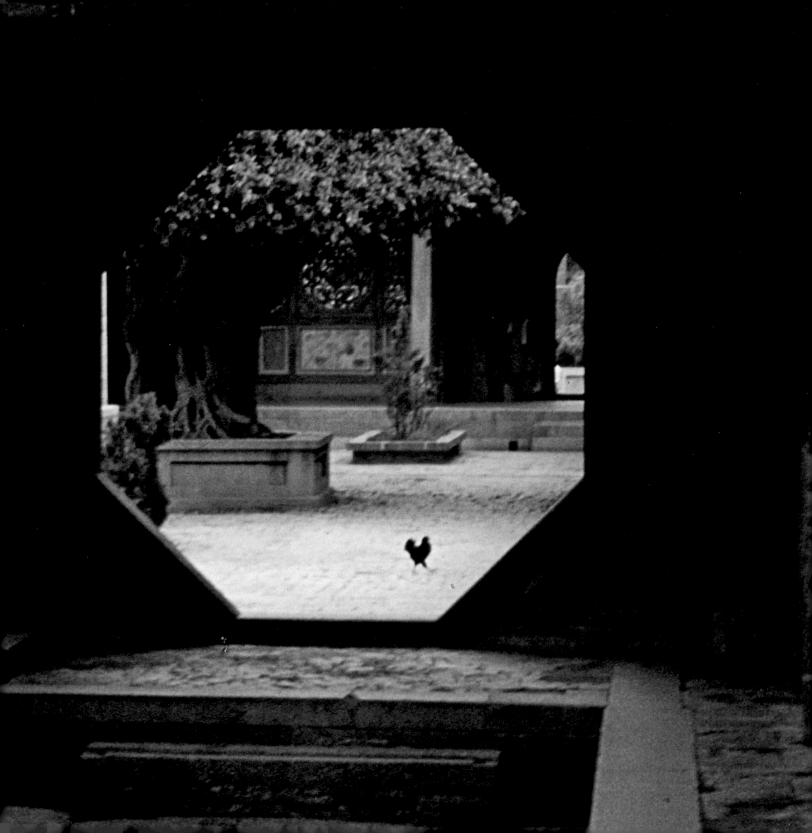

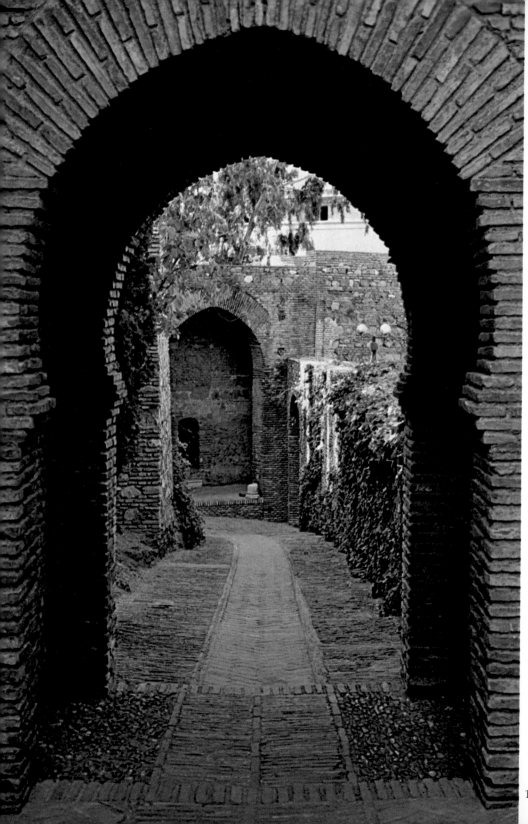

doorways never bring us to a stop; they reveal another prospect.

Those of us obliged to live in large modern cities may contemplate such perfection with some sense of despair. We may live in a highrise apartment block, a veritable monument to security from its electronically-controlled entrance to its sullen corridors of closed doors. We may feel besieged, if not imprisoned, and may envy those lucky enough to own ample houses in the landscaped suburbs. And those in the suburbs, trapped by taxes and rising costs and the need to keep pace with their neighbors' apparent affluence, yearn to escape to a small farm in the country where they could grow their own food. And those still on the farms, meanwhile, long for those times past when farm life was simple and serene and self-sufficient. But of course the one doorway through which there is no escape is the doorway to the past, and what we may feel we glimpse there is largely illusion.

It should never be forgotten that doors were originally conceived as a means of defense, in fear of a limitless unknown world, of savage animals, and of lurking human enemies. During long periods of the thousands of years since, men have been obliged continually to bar their door against barbarism, plague, war, revolution, crime, persecution, and their own superstitious bugbears.

There have been periods of history that may seem in retrospect to have been more stable and less troubled than

our own times, but the glimpses we allow ourselves of such idyllic times are never fulfilled by close examination.

Invariably the stability and comfort and beauty were the privileges of a small élite. In ancient China, where the first extensive civilization flourished, the ornate homes of the nobility were in sharp contrast to the hovels where the mass of peasants struggled to survive. Yet those noble homes had to be built in accordance with a rigid set of superstitions and customs, the siting of their doors and windows governed not by comfort or convenience but by the need to ward off evil spirits and to be properly aligned with the cosmos; even the simple ushering of a guest through the doorways involved a slow and elaborate ritual.

Much as we may admire the majesty of Egypt's tombs and palaces, we should remember that the suitable interment of a pharaoh probably cost the lives of thousands of slaves, some sealed up behind the tombs' vast stone doors to serve their masters on the journey to eternity.

In imperial Rome slaves ensured that patricians could savour life in their opulent villas, with their doors opening to a vista of inner courtyards, cooled by pools and fountains and shaded by trees. But the mass of Rome's plebians lived in multistoried blocks that were bleak even by the frugal standards of our own public housing. The indentured laborers and craftsmen who raised and ornamented the magnificent church doorways of the

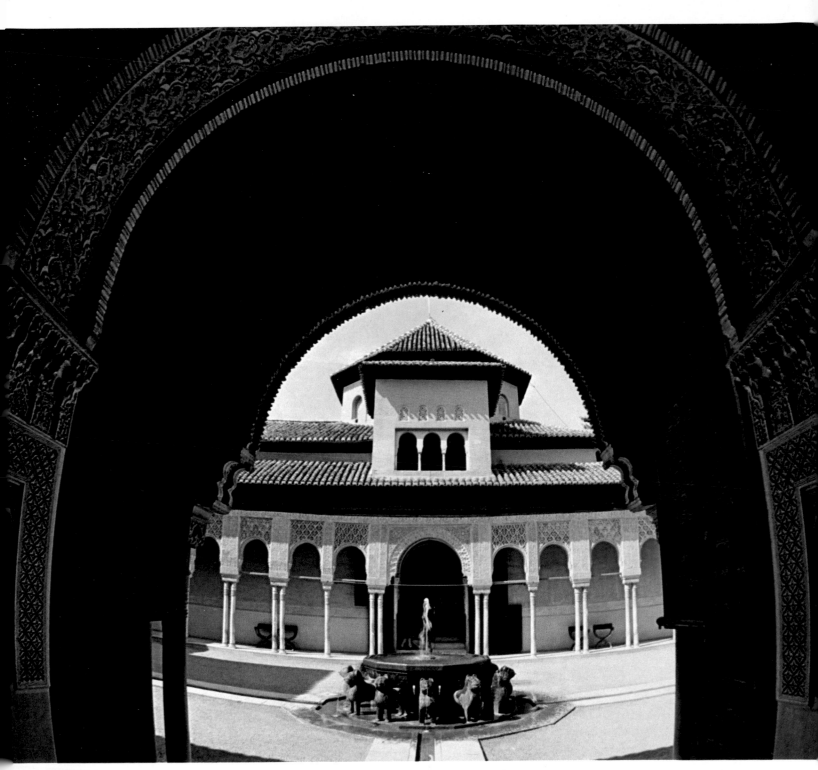

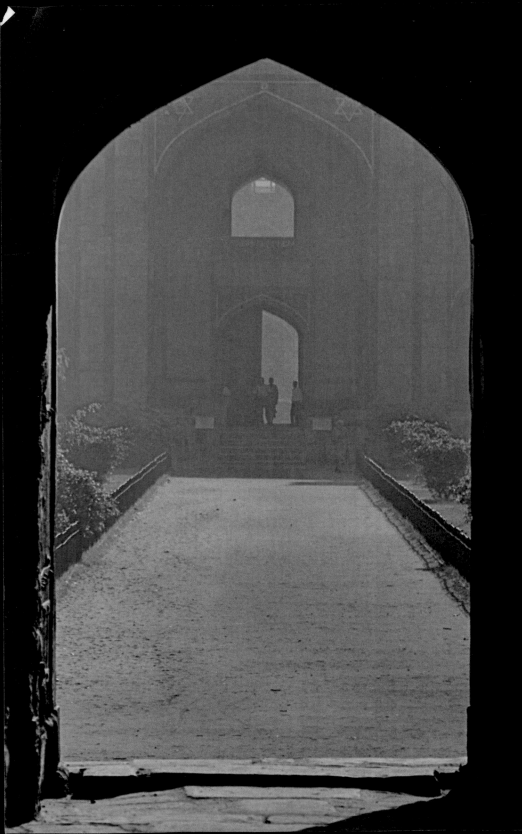

Middle Ages were not even as well housed as the Romans. And within the impressive doorways of Moorish and Mongol palaces were other doorways that rarely opened, behind which the womenfolk lived out their whole lives in service to their masters.

Whatever misgivings we may have about our world, we must be aware that more of us are in a position to involve ourselves in improving it than ever before in human history. When rigid superstition, slavery, serf-dom, and the treatment of

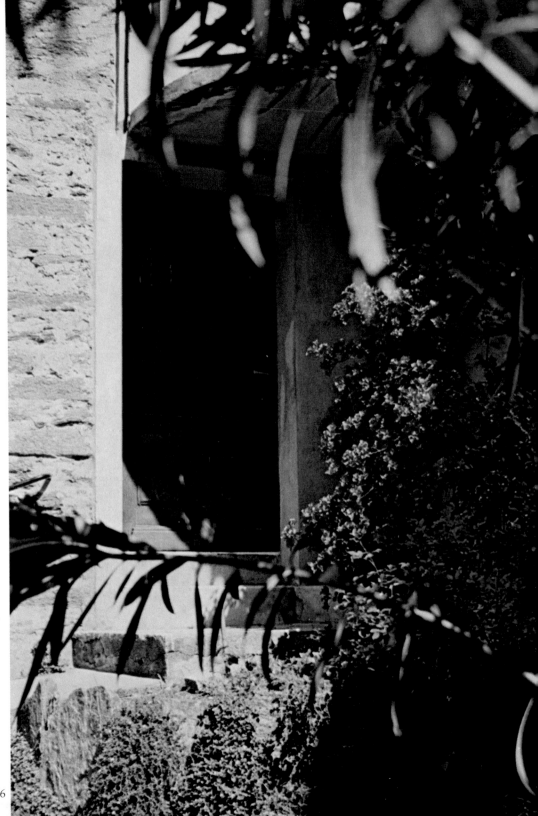

women as chattels became abuses too heavy to be endured, the means were somehow found to bring them to an end. The doorway out of any human problem has yet to prove permanently closed.

More and more of us than ever before have doors we can call our own. We can come and go as we please. And if we feel our doors are unworthy of us, we mostly have the means and the leisure to replace them. If we notice our doors, that is, since doors are amongst those meaningful features of life that we see

156

often and notice seldom.

But we are beginning to notice such details. In many cities people are rallying to resist the destruction of older graceful buildings and their replacement with featureless towers of steel and glass. We need buildings and doorways beside which we can reasonably measure ourselves.

But there are other doors, at a time when it is easier than ever before for men to communicate and to relate, that are continually being slammed and locked. Doors that imperceptibly imprison us and divide us. They are doors reinforced and locked by our fears, superstitions, pride, and prejudices, and only we ourselves can unlock and open them and allow those outside an inviting glimpse of whatever grace, beauty, promise, and humanity we have built within ourselves.

My secrets cry aloud,
I have no need of tongue.
My heart keeps open house,
My doors are widely flung.
Theodore Roethke: "Open House"

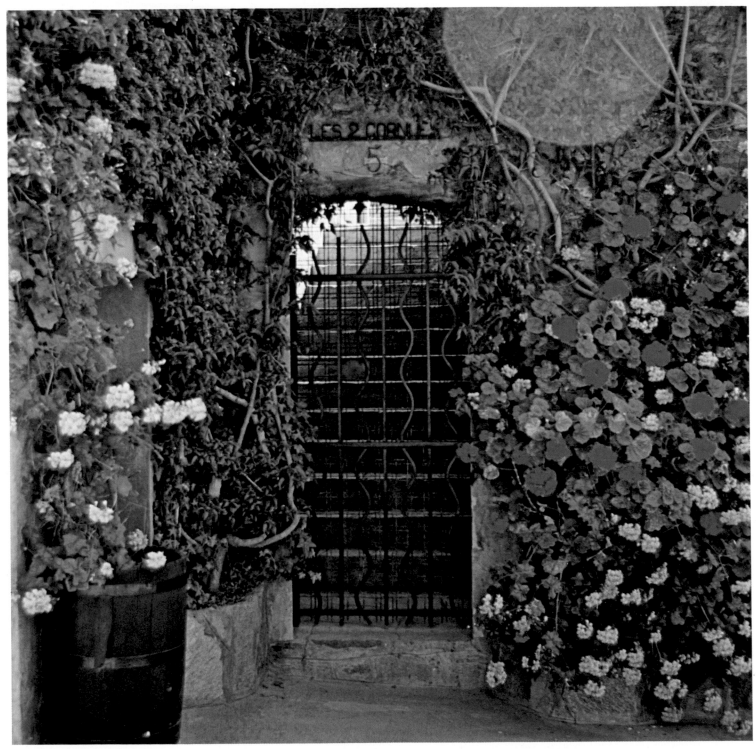

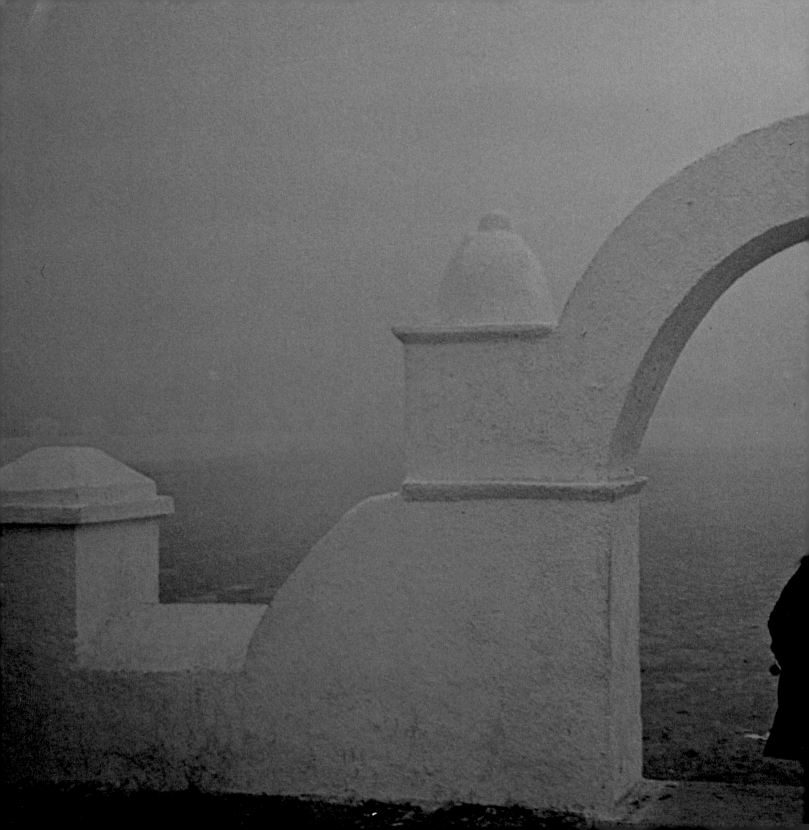

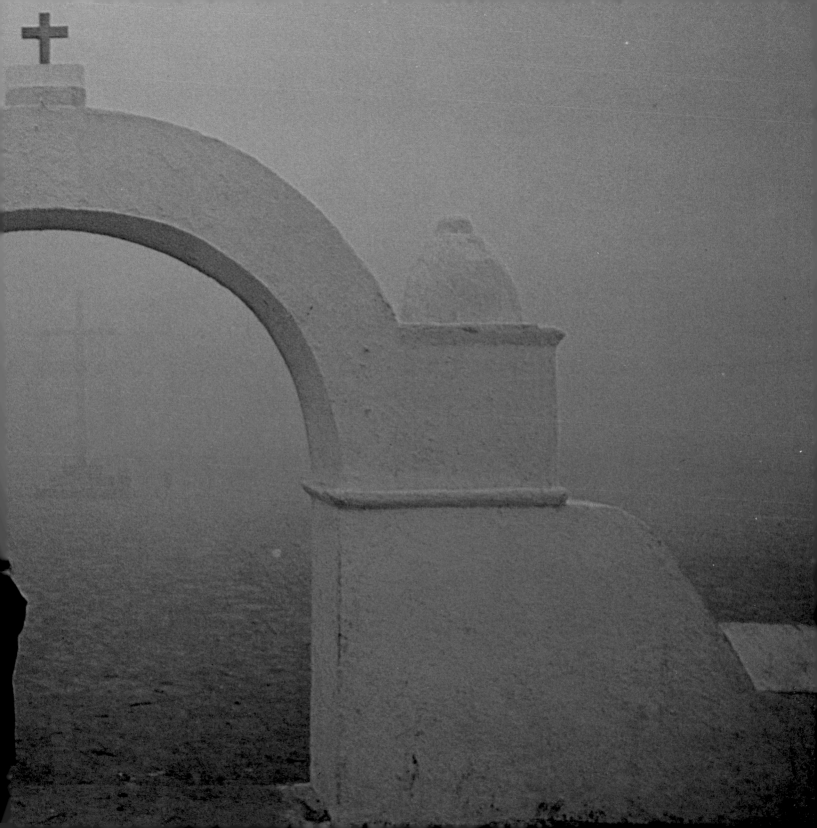

Photographs

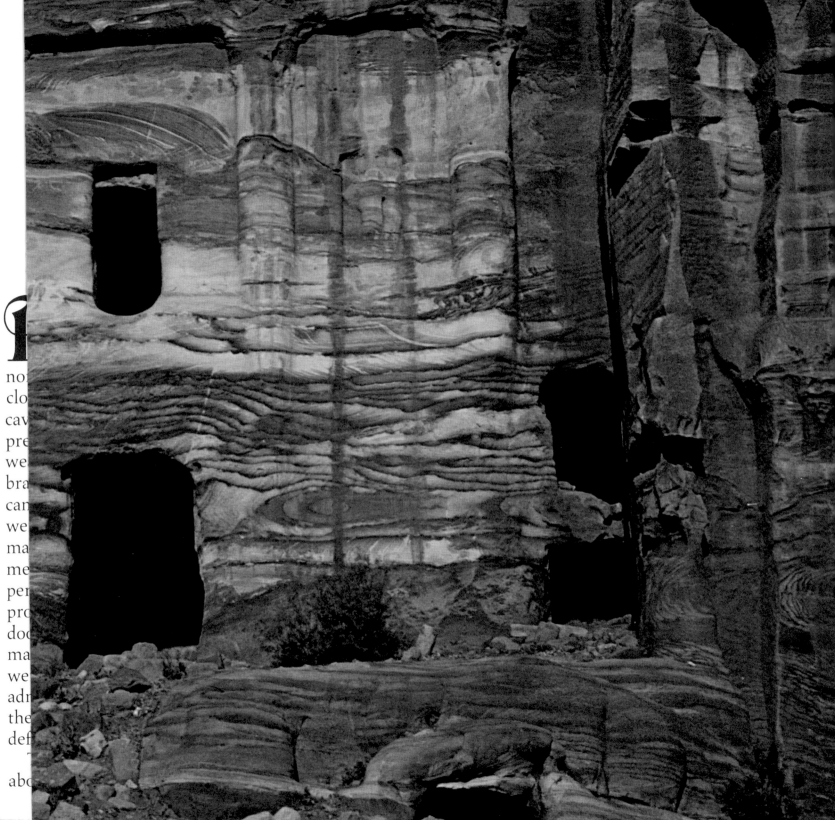

no
clo
cav
pre
we
bra
can
we
ma
me
per
pro
doc
ma
we
adr
the
def

abo

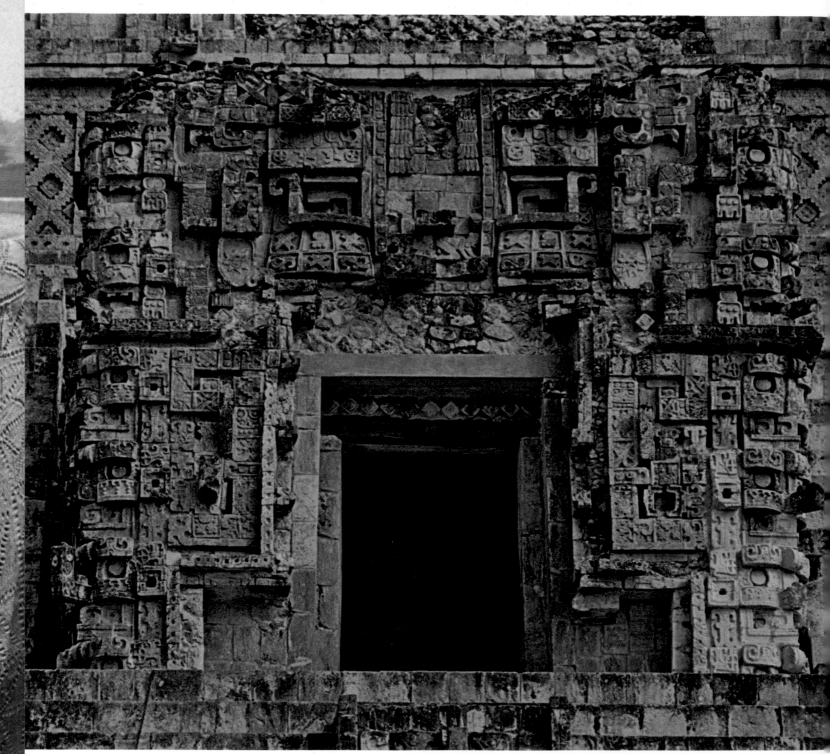

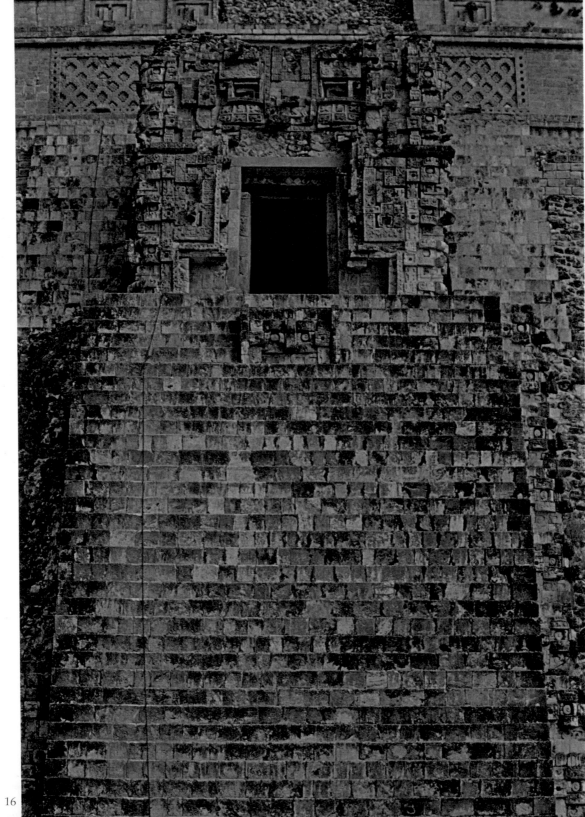

According to archaeologists, the building methods devised in those Near Eastern settlements thousands of years ago still influence European architecture today. The raw materials at hand dictated the methods adopted. Initially walls were shaped directly from clay mixed with straw, then the idea of bricks formed from the same materials and baked in the sun offered builders a greater flexibility. Elsewhere, alongside rivers, tall pliable reeds were plentiful and these, bound in thick bundles and embedded upright in the ground, formed the basic structure of the houses, the outsides being later plastered with mud; the tops of the walls of reed were bent inwards and tied together, forming a vaulted roof and, at either end, an arched opening, which could be filled with reed matting or left open as a doorway. It is believed that the arch, the vault, the dome and the column, which are still common in Western architecture, all derive from that primitive structure.

One material that was not plentiful in the Near East was wood, and wood, because it is relatively light and easy to shape, is ideal for making doors. Since wood also disintegrates rapidly, archaeologists can only presume that the first doors consisted of light logs lashed to cross-stays and wedged into doorways when needed. The next innovation was probably the wooden door frame, intended primarily to support the wall above the doorspace but also providing a jamb to which the crude door could be attached. The first hinges were just thongs of rawhide, requiring the door to be lifted bodily when opening or closing it. It was not until rigid metal hinges were conceived that doors were able to pivot freely as they do today.

Doors have remained basically the same ever since, although there have been many refinements of their form. One instance is what

we call the Dutch door, which is divided half-way up to allow the top half to be opened, admitting light and fresh air, while the lower half remains closed, keeping stray livestock out and straying children in. It seems very probable that doors of this kind were in use long before they were attributed to the Dutch.

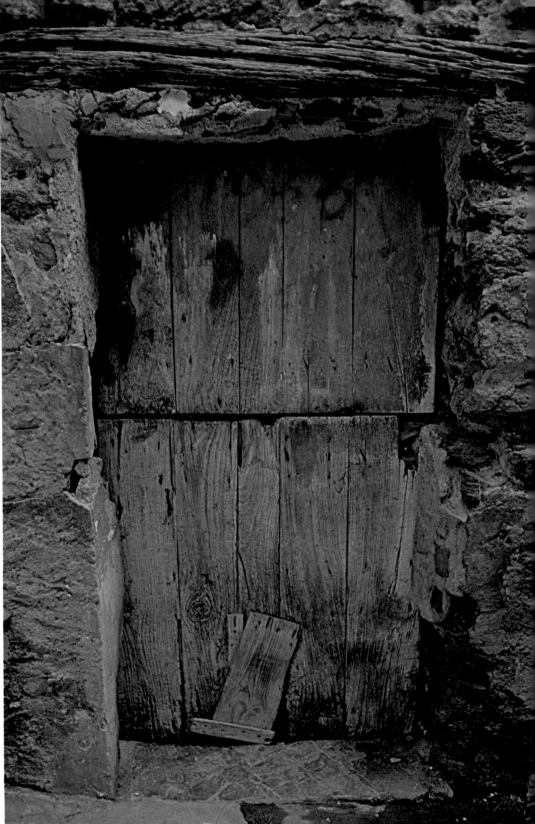

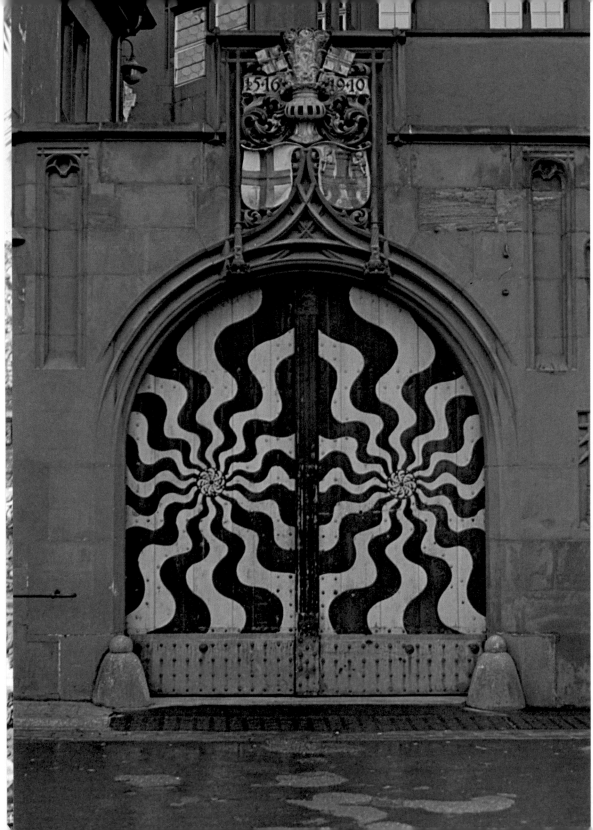

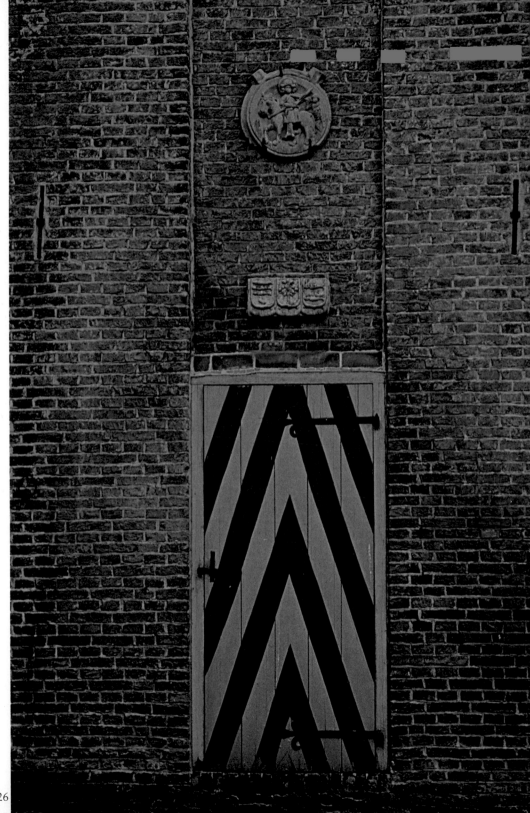

There were times, though, when those who were a power in the land felt no trace of modesty about proclaiming it as clearly as possible. Since few could read, any knight who was anybody wore his heart on his shield, emblazoned in heraldic imagery, along with his blood line, his battle honors and his family allegiances. His castle was his home, and anyone, friend or foe, approaching his gate had no excuse for not knowing what manner of man he had to deal with.

Today only tourists pause, and wonder what it all means.

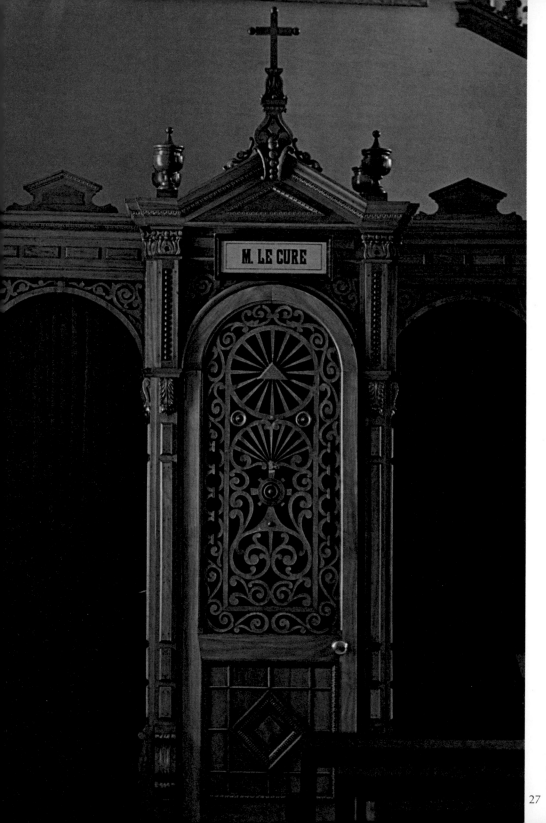

Nobility of course has no monopoly on using its doors to proclaim itself. Monsieur Le Curé within his confessional, behind the closed door that releases sinners from their sins, is as proud of his cross as he would be of any coat-of-arms. He would probably be less than pleased if he were aware that much of the elaborate tracery that graces his door derived originally from pagan symbols, as

27

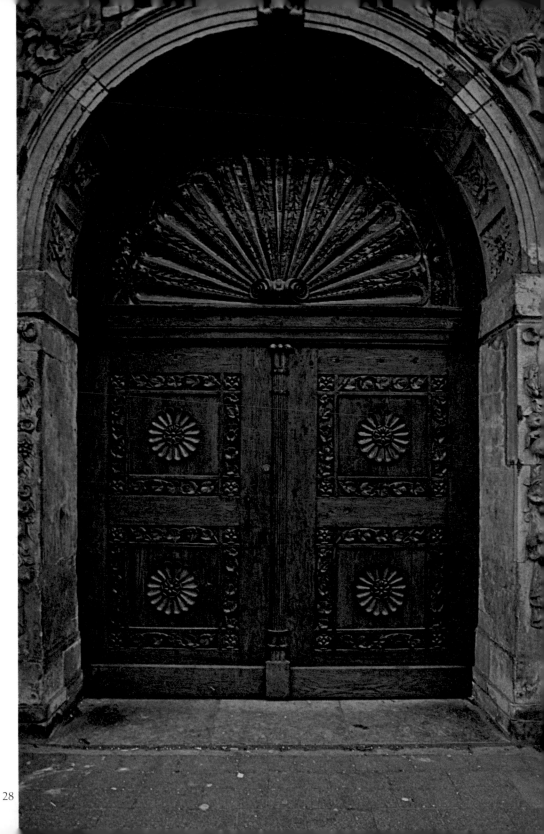

indeed does his cross.

The medieval craftsman
who carved the sunrise motif
within the wide arch of a
doorway was merely copying
a traditional design, unaware
that the tradition reached
back to those days when men
did worship the sun. No more
was the Regency gentleman
aware that the fanlight
installed above his elegant
front door enshrined the
same solar mythology.

28

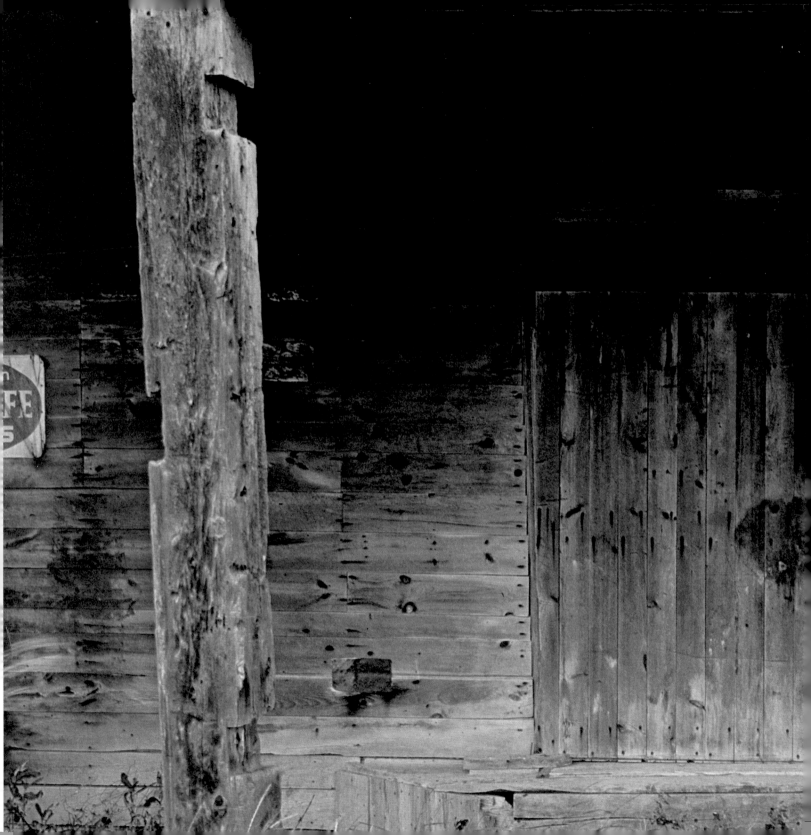

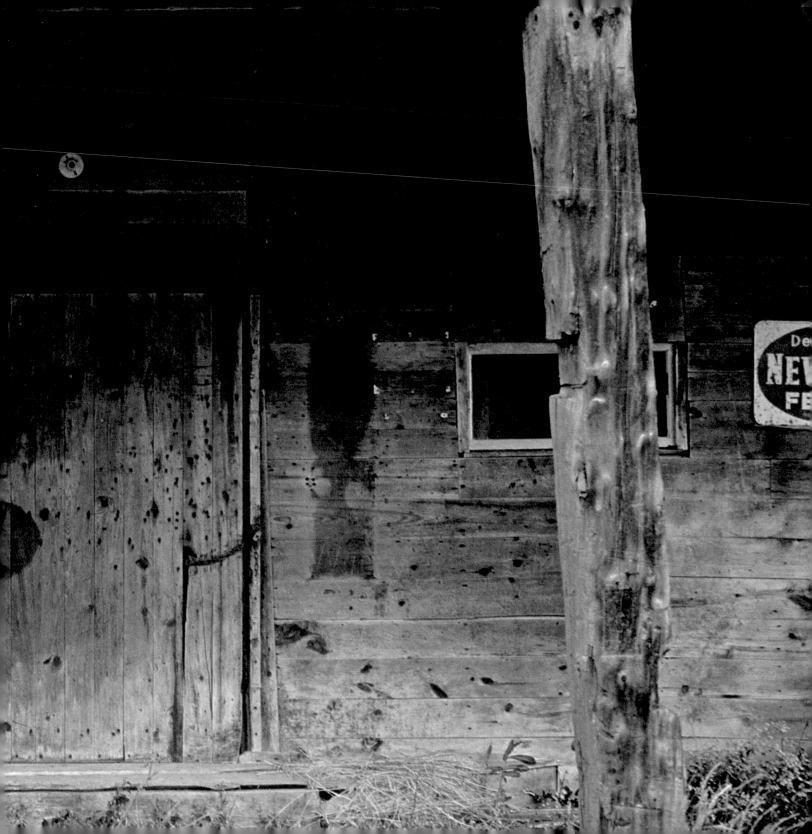

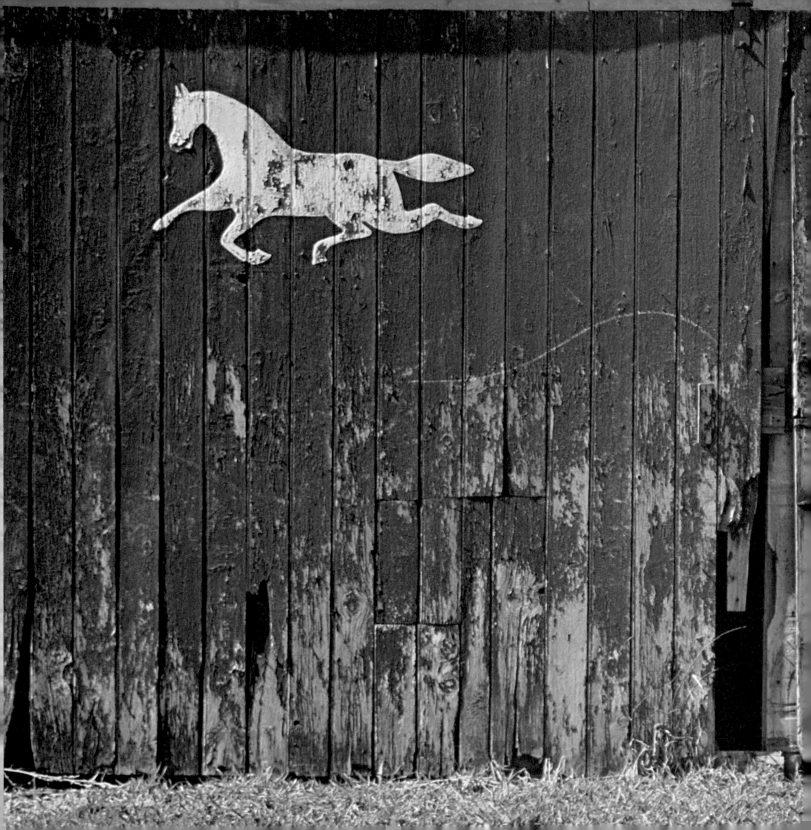

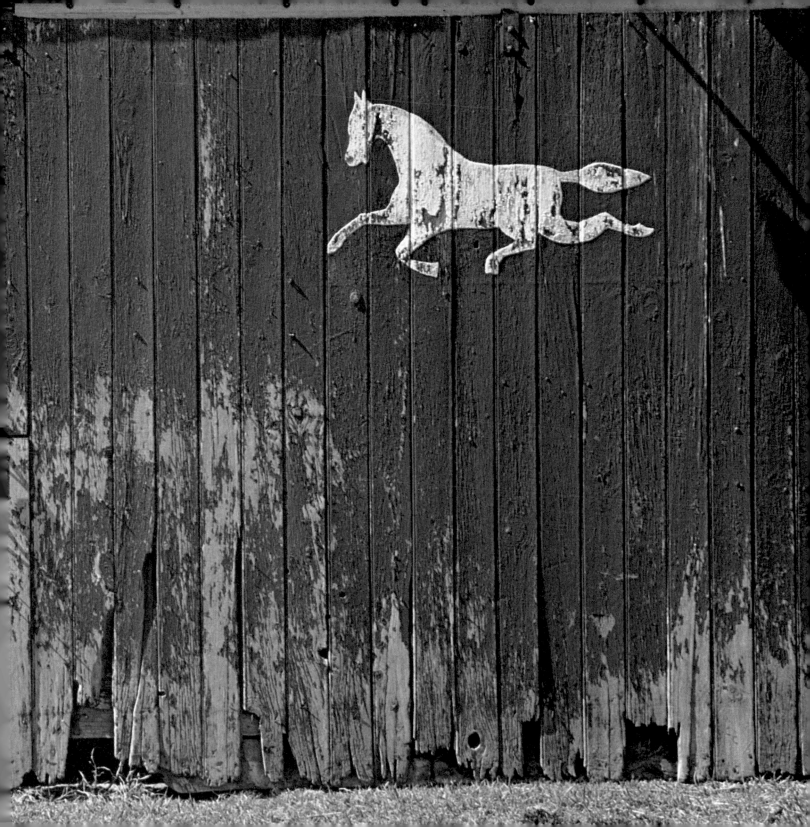

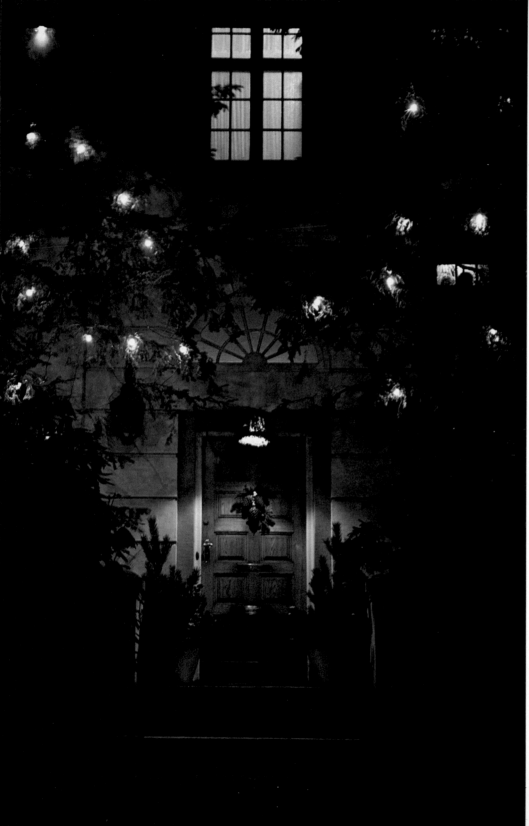

Canadian horse-breeder has a pair of white horses painted on his stable doors.
Is it pure coincidence that in far-off India those identical images are considered protective, the symbols of power and fertility?

Christians in many parts of the world bedeck their doorways at Christmastime with wreaths of holly and sprigs of mistletoe, yet the custom derives from the pagan druids of ancient Britain, who revered such plants for their power to bring fertility and plenty. Corn-husks hung on the door at harvest-time are intended

40

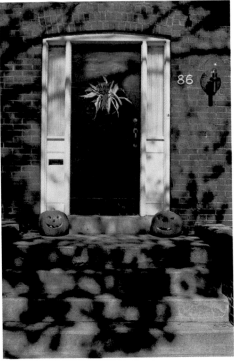

41

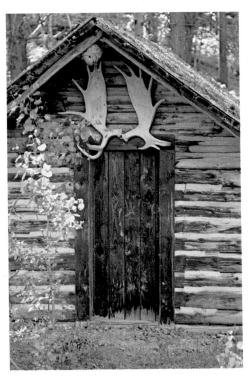

42

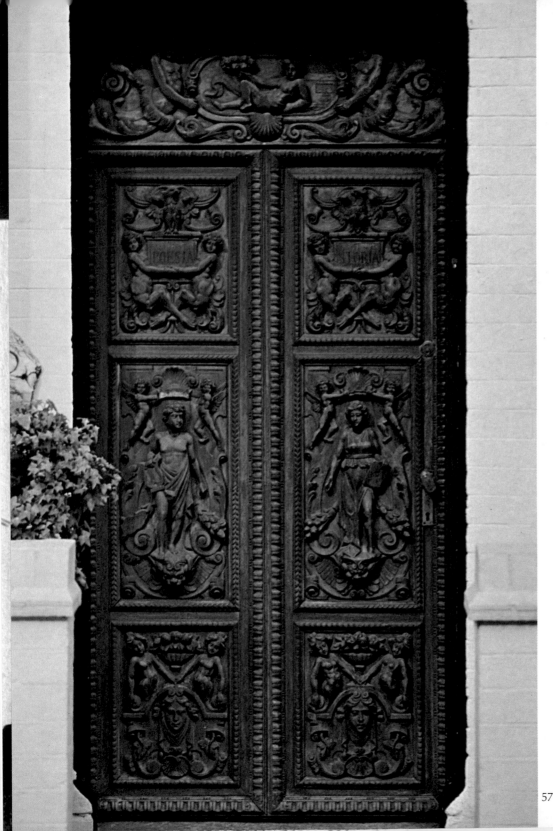

At the zenith of the civilizations created by Greece, Egypt and Rome, architecture took on an appropriate grandeur. Vast temples, tombs and public buildings were graced by doors of matching scale and magnificence. There are records of great ornate doors of marble, of wood and of hollowcast bronze, but while the ruins of these great monuments survive, little trace of the doors has been found. Throughout the Dark Ages in Europe regimes needed to defend rather than glorify themselves and their doors remained functional and sturdy. The Italian Renaissance and the imperial affluence of the Moors, the Spanish, and the French restored some of the classical

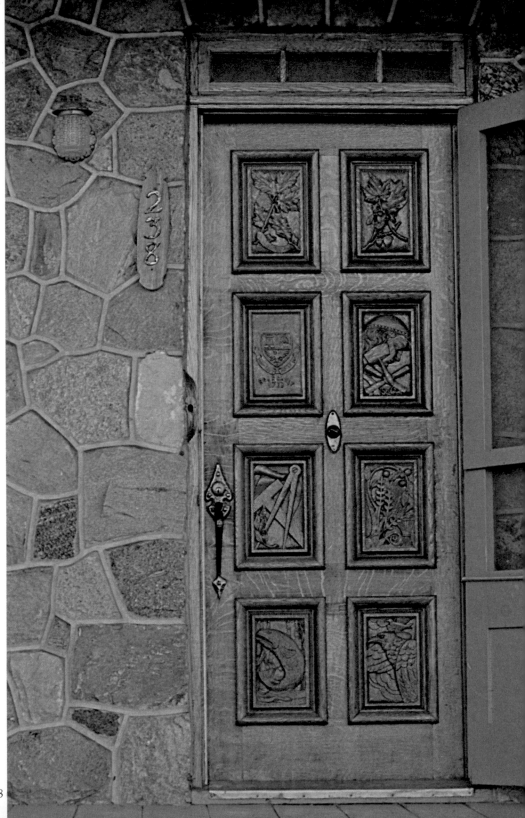

glory to the building of doors, many of which have been preserved as architectural treasures today.

At a more modest domestic level, just as there are homeowners who use their doors to display their importance or their superstitions, so there are others who prefer their doors to reflect craftsmanship, or fashion, or even whimsy.

A beautiful front door, if it costs somewhat more than a fine suit of clothes, remains always on view to neighbors and passers-by and usually outwears more than one owner. Sculptors and wood-carvers are usually hungrier (and more gratified by display of their work) than are tailors, and they are invariably better schooled in the finest traditions of their craft.

58

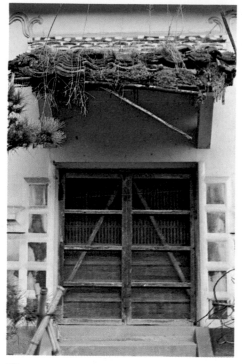

59

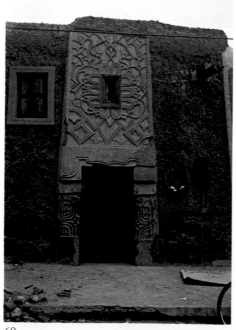

60

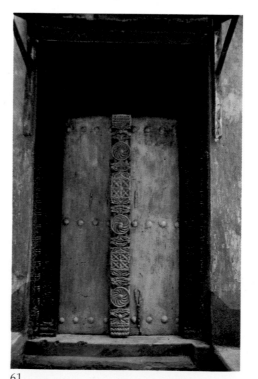

61

Unfortunately in this century the fashion of uniformity has tended to favor the tailors rather than the sculptors.

Even in countries which have no classical tradition of art or which by tradition frown on ostentation, doors and doorways are graced with care and craftsmanship. Whatever is well-made, however simple and of the most rudimentary materials, reflects well on its owner. It need not, like a suburban home, be annually rejuvenated, for in such simple and uncompetitive communities it is acknowledged that a well-made door, like a good wine, improves with age.

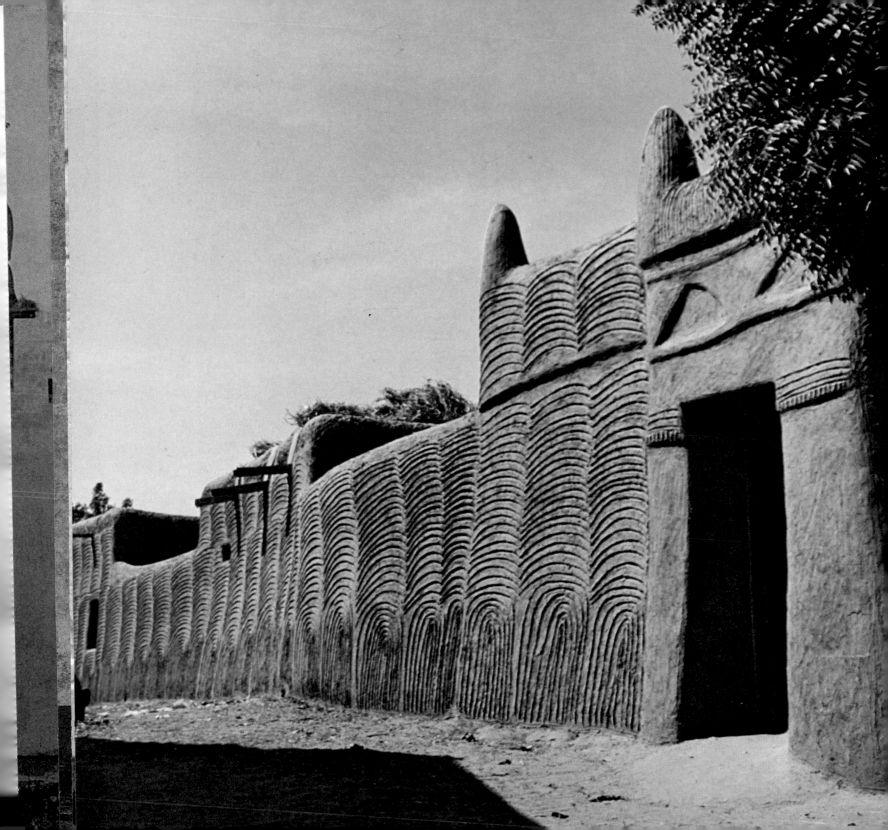

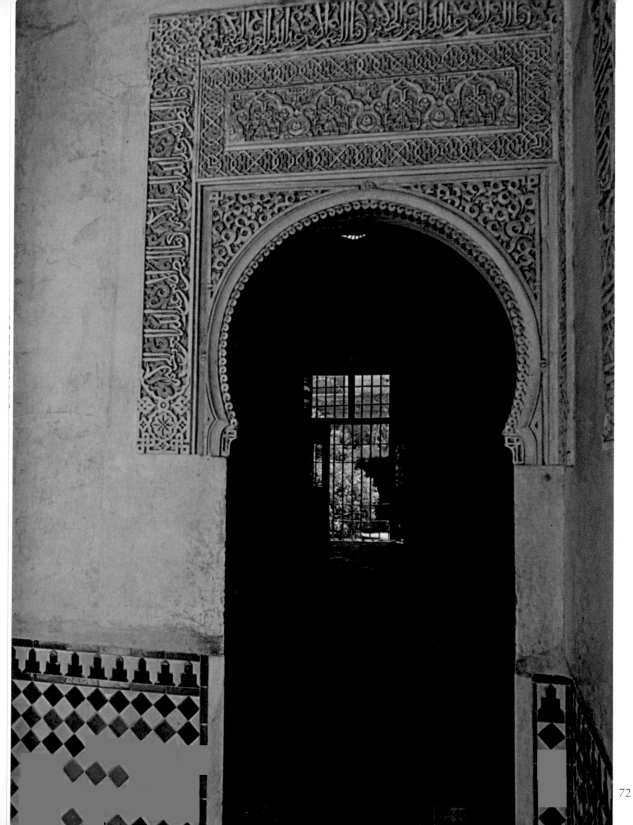

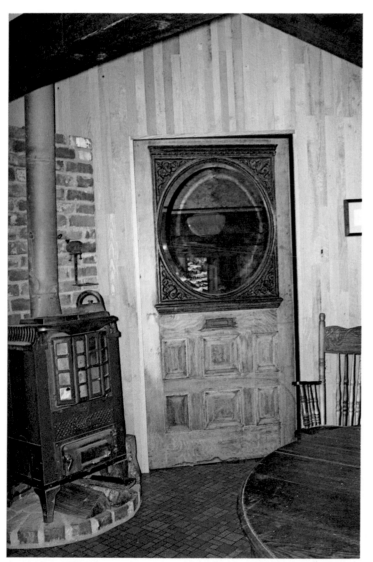

73

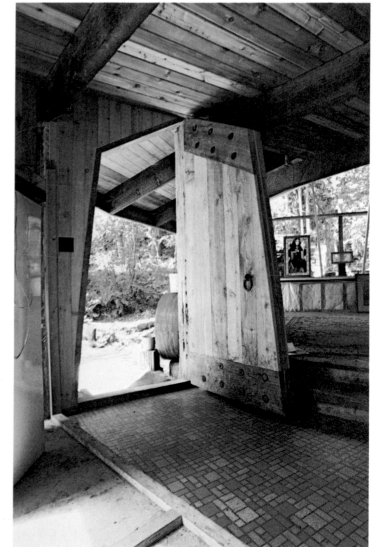

74

Photographers